VAN GOGH

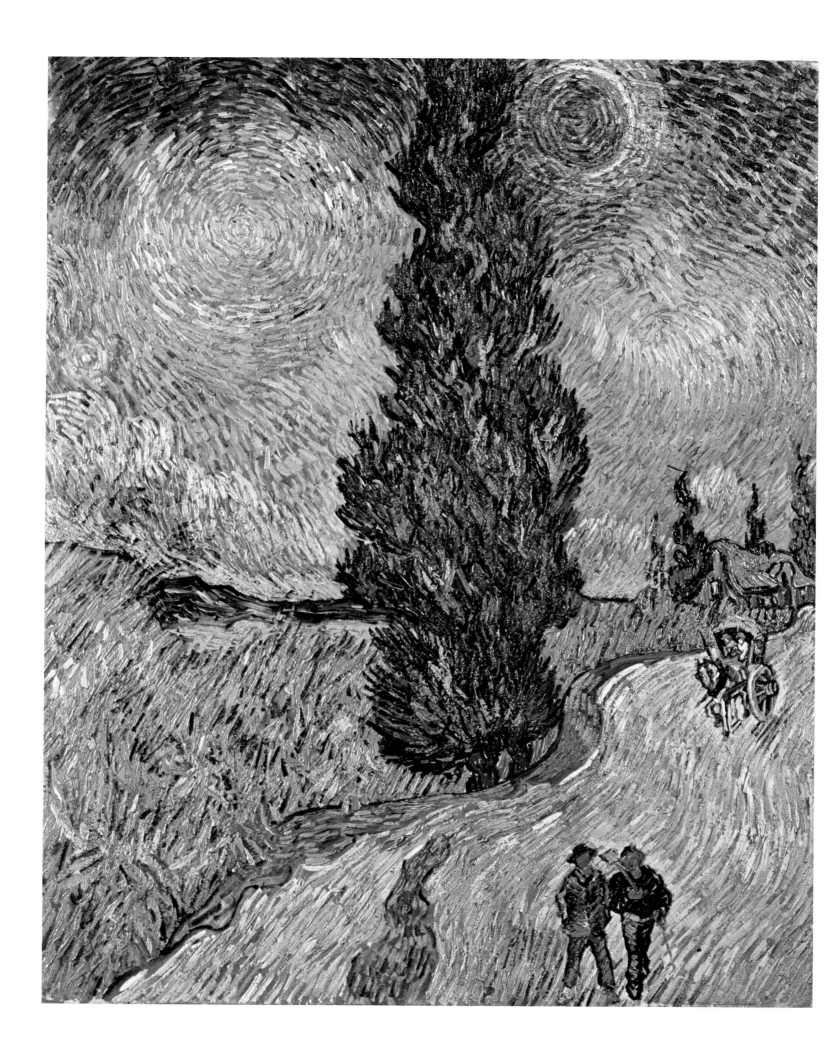

VINCENT
VAN GOGH

MEYER SCHAPIRO

ABRADALE PRESS

HARRY N. ABRAMS, INC., *Publishers*

Library of Congress Cataloging-in-Publication Data

Schapiro, Meyer, 1904–

Vincent van Gogh / text by Meyer Schapiro.

p. cm.

ISBN 0–8109–8117–3

1. Gogh, Vincent van, 1853–1890. 2. Painters—
Netherlands—Biography. 3. Impressionism (Art)—
Netherlands. I. Gogh, Vincent van, 1853–1890. II. Title.
III. Series.

ND653.G7S386 1994

759.9492—dc20

[B] 94–1477

This 1994 edition is published by

Harry N. Abrams, Incorporated, New York

A Times Mirror Company

Printed and bound in Japan

TABLE OF CONTENTS

VAN GOGH

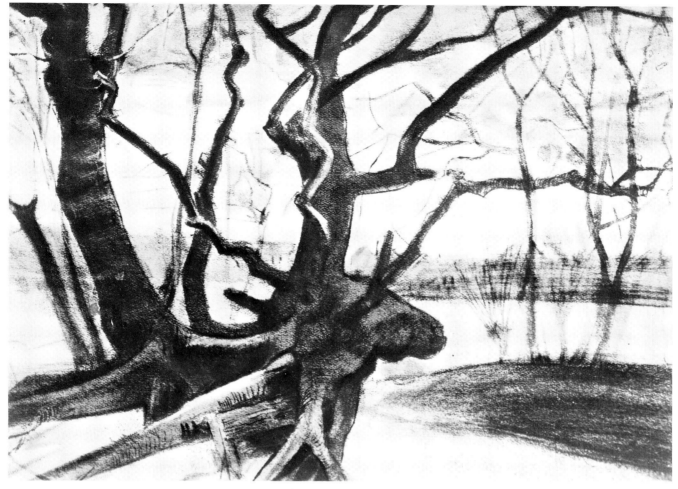

STUDY OF A TREE

VINCENT VAN GOGH
by MEYER SCHAPIRO

THE singularity of van Gogh's life lies in the fact that art was for him a personal destiny in the fullest sense: first as a heritage in his family of art dealers, which brought him early into touch with art and deter-mined his unsuccessful profession as picture salesman—the more successful profession of his younger brother, Theo, who was to play so crucial a role in Vincent's life as his only support; then as a choice made for personal salvation, after he had failed in another hope, a religious mission as an evangelist among the poor miners of the Borinage. This choice on which he staked his life sent him back to Holland among the peasants, pushed him on to Paris for maturation, to Arles for release from the conflicts with Parisian artistic life, to the asylum of Saint-Rémy for recovery from a crisis in Arles (set off, perhaps, by his troubled relation to his friend Gauguin), and to Auvers, in preparation of the return to his Paris world—and there to suicide, which was due, in part at least, to guilt for his brother's support.

What is most important is that van Gogh converted all this aspiration and anguish into his art, which thus became the first example of a truly personal art, art as a deeply lived means of spiritual deliverance or transformation of the self; and he did this by a most radical handling of the substance of his art.

In doing this he responded, as others did in his time, to the new function of art in the West, as an alternative to older moral-religious means. But failing in this heroic effort to save himself, as his suicide shows, he nevertheless sealed this function by his great example and the authenticity of his work; he showed that art could reach that intimacy and intensity of the striving, loving, anguished self.

His career as an artist is a high religious-moral drama and not only a rapid development of a style and new possibilities of art. Every stage of his art has a profound personal meaning, it engages him completely, and could only have been produced in the place where he lived and worked; his Holland art is possible only there—a life-space, a full milieu, is evident in it.

In Holland where he first came to art, his decision, following a period of religious and moral preoccupations when his whole aim was to give himself to others, to love and to be worthy of love, made of him a peasant painter. He was drawn to art not as a skill or means of livelihood, but as a communication of the good. And with characteristic intelligence and will, he also made this a period of ardent preparation, unflagging study and self-trial. His letters from this time—a vast work of self-revelation, which may be set beside the works of the great Russian writers, masters of the confessional genre in literature—show his remarkable awareness of artistic problems and his urge to solve them.

Maturing as an artist, the untenability of peasant-painting became clear to him. What he abandoned in the end was not the basic human program, only its historically and personally unviable form; for in his later works in France he returned to the original ideals, although in a different style. But in this break with

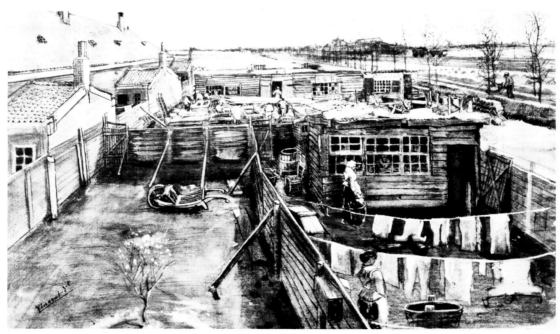

BEHIND THE SCHENKWEG, THE HAGUE *Collection State Museum Kröller-Müller, Otterlo, The Netherlands*

12

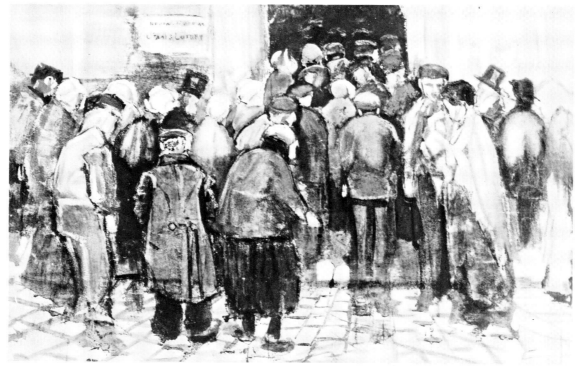

THE STATE LOTTERY National Museum Vincent van Gogh, Amsterdam

Holland, he reproduced the change going on in society itself; that old life was no longer creative and surely an obstacle to an artist's growth. He yielded to the new art of his time, but he yielded in order to transform it. In Paris he discovered the senses, the world of light and color which he had lacked, and which he now welcomed as a release from past repressions and a narrow, no longer vital, religion and village world.

But he soon put these discoveries in the service of his strongest impulses, which were not at all in line with Parisian art, although Paris was looking for an art like his, having outgrown Impressionism, an art no longer serviceable to the souls of rebellious and aspiring, disillusioned men.

His greatest works belong to this subsequent art; but his works in Paris and Holland—and among these are his wonderfully earnest, powerful, brooding drawings—also hold our eyes.

His work in Arles is a new art—his first new art, for what he had done before belonged to tradition. It revives certain features of his Holland painting, but transfigured by what he had learned in Paris, or could now learn by himself thanks to his Parisian experience. His first aim was intensity, a firm, clear, advancing image exalted by daring colour; the objects are now felt in their permanence and inner force; the drawing is more virile and decided. Light is no longer a power external to things, which subdues them and dissolves them, but an emanation from the flattened shadowless objects, the inherent luminosity of their intense local color, which identifies them as unmistakably as their form. It is a kind of vitalism, an art of unbounded joy in life, the more passionate lyric of an outdoor painting directed towards objects rather than to an impalp-able atmosphere and light. The sun in this brighter world becomes a material thing, the most vivid and radiant object of all. If the sombre peasant-painting in Holland pictured man after the expulsion, doomed to a wearisome labor, the painting of Arles was a return to Eden.

The pictures of the first months in Arles, in 1888, are still Impressionist, a lyrical painting of orchards in blossom, beautiful trees, the river and the bridge, in tiny strokes and light tones, with high-keyed shadows; the vision is close to the Paris paintings, only more concentrated on a beautiful, absorbing, poetic object. We notice soon how the brush begins to draw as well as paint, tracing strong outlines in colored strokes, which stand out from the colored touches that fill the space between the bounding lines; lines that become firmer, more accented, defining larger areas of saturated color, and fixing these as a cohesive marquetry of pigment on the canvas plane.

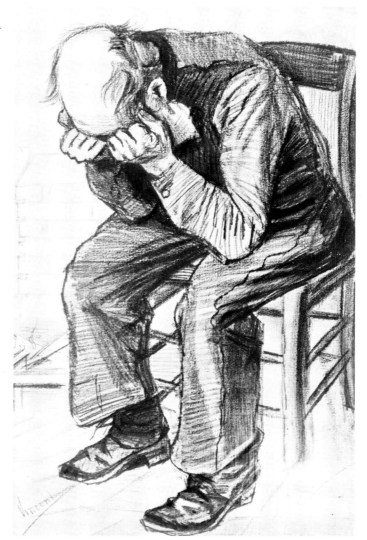

Vincent thought of his new art as both Impressionist and Japanese—he called the Impressionists "the Japanese of France"; but he came to see that it was neither and that something new had come into being. The Impressionist method, founded on delicate observation of high-keyed atmospheric tones, could not admit the violent tones of pure color, especially of yellow, which he applied to an entire unbroken ground. The older artists OLD MAN IN GRIEF *National Museum Vincent van Gogh, Amsterdam* broke up the world into tiny bits, while his own tendency was to re-instate the objects in all their fullness and strength. Given the choice, van Gogh risked the intensity and sacrificed the charming softer accords through which Impressionism acknowledged its membership in the family of French styles.

He was encouraged in this radical break with his past, Dutch as well as Parisian, by the example of Japanese art, which enjoyed in 1888 its highest prestige in France. He had already come upon the modern Japanese wood blocks in 1885 in Antwerp where he had mounted them on his walls. This art enchanted and haunted him all through his stay in Paris; he was perhaps the only painter of that time to copy the Japanese prints, transposing the thin substance of works by Hiroshige and Hokusai on to canvas in the denser medium of oil. Japan was for him a paradise of art and, when he left for Arles, his eye was set for what he thought would be a Japanese landscape. He looked for blossoming trees, pure blue skies, landscapes cut prominently by bridges, natural contrasts of big areas of bright color; and when he found them in Provence, he wrote to Theo that the region was indeed another Japan and that his own art, which rendered its loveliness, was a continuation of the Japanese.

The taste for Japanese art in the 1880's belongs to both Impressionism and to the reaction against

Impressionism—a fact that teaches us how loose may be the affinities of style which permit copying and the influence of one art upon another. For the older Impressionist generation, the novel charm of Japanese art lay in its elegant lightness, its themes of spectacle, and the glancing vision in which the world was seen obliquely and piquant figures were cut by the frame, forming irregular partial patterns, very congenial to Western artists who repudiated the rigidities of formal composition and decomposed the landscape into delightfully shapeless spottings of color; for the younger artists, men like van Gogh and Gauguin and Lautrec, who were turning away from Impressionism, the Japanese prints were beautiful also in their precise silhouettes and flat pure colors in strong contrasts, that is, in their medieval linear and shadowless aspect.

We see today that what distinguishes later nineteenth-century European art from the Japanese prints (beside the focused perspective, traditional in the West, but unknown in Japan), is the live brushwork, the vibrant fabric of touches, which is its most personal element and persists even in the more flattened Western styles. It is a factor we recognize at once in van Gogh's copies of Japanese prints. Where van Gogh parallels some details of Japanese art—so limited in liberty of judgment and response, so slight in spiritual and critical content—he strikes us as more earnest and attentive.

Still, like other advanced Western artists, he found in the foreign art a support for his own aims, a practical justification of his independence of established forms. It was Japanese art that gave van Gogh, as he said, the "authority" to introduce contrasts of pure black and white among the spectral colors. The exotic object is fascinating to rebellious spirits; in almost every great movement of art since the French Revolution, a distant newly discovered style has been fervently admired—from the Roman works in the generation of David to the African and Oceanic arts in our own day—just as in the eighteenth century the

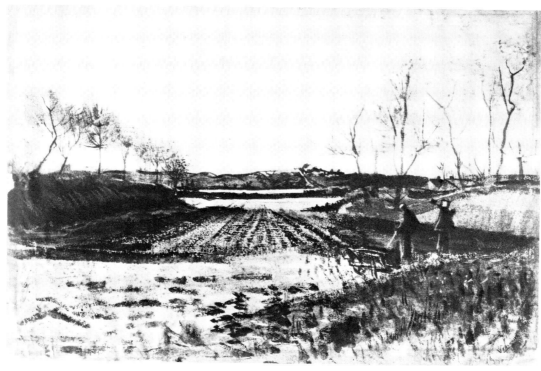

VEGETABLE GARDENS NEAR THE DUNES *Collection State Museum Kröller-Müller, Otterlo, The Netherlands*

15

examples of China and savage America encouraged in France a libertinism of thought unknown in these exotic cultures. By admitting the foreign creations to the highest status of art, the closed tradition is opened and the individual is freed from the constraint of local precedent.

One Western precedent van Gogh retains and even revives. It concerns, precisely, portraiture, that searching of the individual, whose self-awareness and social freedom had made possible his great liberty in art. During the year in Arles, Vincent painted some forty-six portraits of twenty-three people, including himself. We are reminded of a project of his in Nuenen, to paint fifty peasants' heads. This love of portraiture does not surprise us in a man so deeply attached to humanity as van Gogh. As he painted these people of Arles, he conceived an enthusiastic program of portraiture for modern painting. He expressed to Theo his belief that the future of modern art lay surely in this field. Memories of the great portraits of Rembrandt, his admiration for Hals, were awakened during this spontaneous return to the portrait theme. A return it was, as he himself knew, for the direction of art then was away from the study of the human face.

We can follow the decline of portraiture within Impressionism, the art to which van Gogh assumed allegiance. The Impressionist vision of the world could hardly allow the portrait to survive; the human face was subjected to the same evanescent play of color as the sky and sea; for the eyes of the Impressionist it became increasingly a phenomenon of surface, with little or no interior life, at most a charming appearance vested in the quality of a smile or a carefree glance. As the Impressionist painter knew only the passing moment in nature, so he knew only the momentary face, without past or future; and of all its moments, he preferred the most passive and unconcerned, without trace of will or strain, the outdoor, summer holiday

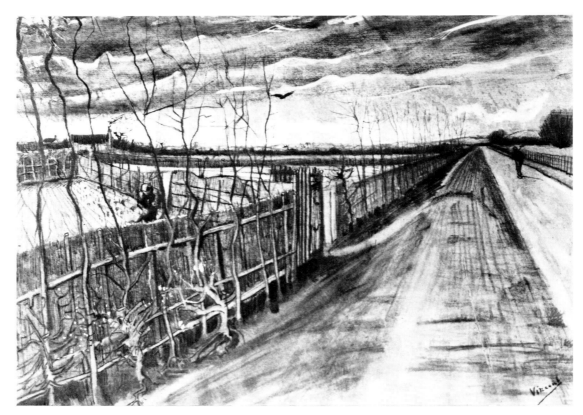

A ROAD NEAR LOOSDUINEN *National Museum Vincent van Gogh, Amsterdam*

A VIEW AT SCHEVENINGEN *National Museum Vincent van Gogh, Amsterdam*

face. Modern writers have supposed that it was photography that killed portraiture, as it killed all realism. This view ignores the fact that Impressionism was passionately concerned with appearances, and was far more advanced than contemporary photography in catching precisely the elusive qualities of the visible world. If the portrait declines under Impressionism it is not because of the challenge of the photographer, but because of a new conception of the human being. Painted at this time, the portraits of van Gogh are an unexpected revelation. They are even more surprising if we remember that they were produced just as his drawing and color were becoming freer and more abstract, more independent of nature.

In their revival of portraiture, van Gogh's paintings belong to a sentiment of the individual which is clearly of his time; it would be inconceivable before the 1880's, yet rests on the previous art which had seemed to be the end of portraiture. Vincent's portraits, like Lautrec's, were not commissioned, but a free choice of the artist. They were not destined for the sitter, like the older portraits which celebrated their subject in his social presence and strength, by showing him as a figure of power, profession and imposing appearance. They are distinguished on the contrary by their openness and outdoor quality; the subjects are for the most part plain people, like the peasants who have attracted the artist by some trait which inspires him. Or, rather, it is not a particular trait that makes them worth portraying, but their humanity alone, their accessibility to Vincent's hunger for friendship and affection. "It lets me cultivate what is best and deepest in me," he said of portraiture, while doing *The Postman Roulin* (page 61). Their individuality is already given in their humanity; to be human is to be unique as leaves on the same tree are unique. His sitters are therefore scrutinized deeply for their peculiarity, and presented with great conviction about this point. They are shown simply and directly, without affectation; even the most brilliant designs of the canvas emerge in the

17

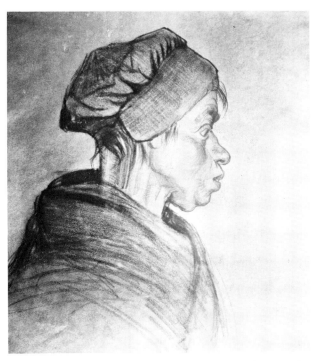

PEASANT WOMAN *National Museum Vincent van Gogh, Amsterdam*

portraits with no apparent effort of arrangement, as inevitable results of natural postures. His people come forward to the plane of the canvas itself; they look at us or turn away without self-consciousness, or if there is such, as in the stiff pose of Roulin, it is a part of the personality, which has been truthfully stated. Peasants, young people, a baby, a mother, a zouave, a neighbour, a one-eyed man, perfectly anonymous folk are portrayed with the same unfailing sympathy, but also with a penetrating realism, an insight into the wear and tear of life. These are the first democratic portraits and would have pleased Whitman especially. They have no real forerunners in old art; the great portraits of the bourgeoisie after the French Revolution are still formal and often heroic, showing the sitters as the successors of the old nobility, always celebrated in their best clothes and manner.

It required, however, his intense love of simple people, already manifest in his studies of the Dutch peasants, to convert the Impressionist directness and openness, which came near abolishing portraiture, into a new means of portraiture as an immediate penetrating intuition of the human, without the deformations of self-importance.

The portraits of van Gogh would not be what they are as human revelations without their startling color. And this holds also of the best portraits of the twentieth century. Van Gogh has done away not only with the dark shadows of older portraiture—always tempting to a portraitist because of the dramatic effect of such contrasts in the human face—but also with that smoothness of the paint and the represented skin which has been so important in the past. In modern portraiture something of the mystery and irregularity formerly won through strong light and shade has been transferred to the rough pigment texture; surprising chords of red and green, which give the face the quality of extraordinary landscape objects, also take the face into the open air and convert the skin into a coarser, more reactive substance, a spectrally colored world subject to sudden change and the interaction of passing elements. The new span of colors in the face, detached from a particular atmosphere or sunlight, operates as a keyboard of suggestive feelings, more richly expressive than the fine modalities of the skin itself. There takes place a vague passage from color to character and from character to color, which is an intimate means of portraiture, on another level than the forceful drawing of the clearly defined features, the color being more variable within images of the same person like the light and shadow in older portraits. As the landscape assumes for an Impressionist painter a multiplicity of aspects, seizable only through different colorings, each conveying another mood as well as moment, so the new coloring of the face, in replacing the eternal aspect of the skin and features and their attractive delicacy, opens the way for a poetic searching of the personality in its varied course of feeling.

The intense colors of many of van Gogh's backgrounds—in the portraits, flowers, and still-life pieces—are not taken directly from nature. They are an arbitrary choice and seem to contradict the realistic precision of his rendering of the objects. A struggle arises between the intensity of the forms of the heads or plants and the intensity of pure, unbroken color in their background. This background comes forward, radiates, and threatens to displace the objects in our vision.

In these daring backgrounds of brilliant yellow and deepest saturated blue, we discover a parallel to the great mosaics of the early Christian and Byzantine period. There Christ and the saints, with faces of a great seriousness and spiritual authority, are immobilized and isolated like statues against a broad field of blue or gold, a background which represents no familiar space, but by its abstractness and intensity lifts these figures out of the realm of a conditioning everyday world. It transfigures them, provides for them an adequate ambience, pure, solemn, and absolute. The gold is an ideal semblance of light as a divine sub-stance, the more recessive blue suggests a distant heavenly space or an inwardness of spirit restored to its celestial source—the blue of the sky absolutized in color, almost to the state of darkness.

In van Gogh's letters, these backgrounds of yellow and blue are mentioned as symbolic colors: the yellow is pure light and also love; the blue, an infinity like the night sky. He tells how, if he had to paint an image of an artist friend whom he loves, he would begin by painting him as he is, as faithfully as he could; but then, to complete the work, he would be "an arbitrary colorist". "I exaggerate the fairness of the hair, I come even to orange tones, chromes, and pale lemon yellow. Beyond the head, instead of painting

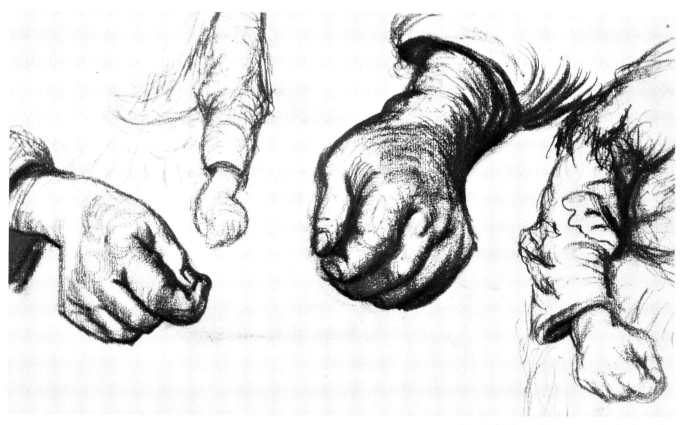

STUDIES OF HANDS *National Museum Vincent van Gogh, Amsterdam*

the banal wall of the mean room, I paint infinity, I make a plain background of the richest, intensest blue that I can contrive, and by this simple combination of the bright head against the rich blue background, I get a mysterious effect, like a star in the depths of an azure sky."

In rediscovering the principle of the older religious art, van Gogh was not inspired by a supernatural belief; he built rather upon his deep feeling for nature and man. It is this fact, insufficiently recognized in comparisons of modern and early Christian art, that distinguishes the subjective character of modern art as a whole from the subjectivity of the older arts. Although influenced by his religious past, van Gogh's search for transcendent elements in his art proceeds from sensory experience and from his passionate love of nature and simple human beings, who have no privileged status beyond their humanity and goodness. He has found a direct approach to these symbolic ultimates of color in the bright sunflowers and in the deep Provençal sky.

Remote from doctrine, rejecting as reactionary and unauthentic the new religious art of his friend Bernard, van Gogh was able to create an image of man endowed with qualities of the sacred figures in the greatest Christian art.

This at least was his aim. He thought often of the affinity with religious imagination in his art. "And in a picture I want to say something comforting as music is comforting. I want to paint men and women with that something of the eternal which the halo used to symbolize, and which we now seek to give by the actual radiance and vibrancy of our colorings."

The demonic and evil too entered his symbolism of color. Describing *The Night Café* (page 71), he wrote his famous line: "I have tried to express the terrible passions of humanity by red and green."

For our eyes, van Gogh's are the first brightly colored paintings of the nineteenth century. Seen against

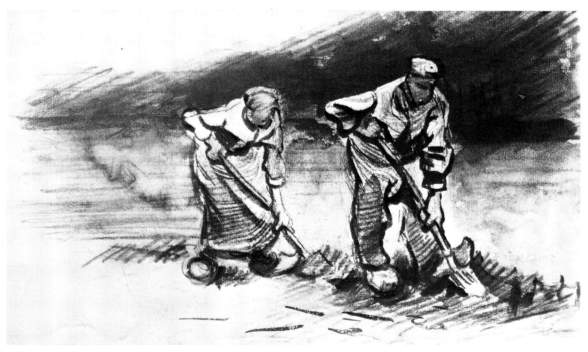

PEASANTS DIGGING *Collection State Museum Kröller-Müller, Otterlo, The Netherlands*

the browns and subdued greens of older art, the color of the Impressionists had appeared to their contemporaries shrill and loud. To-day, beside the paintings of van Gogh from Arles, the Impressionist coloring looks finely greyed with soft nuances and the re-duced intensity that comes from the whiten-ing of tones in strong sunlight. Van Gogh's pure colors are a revolution in an art which had made much of purity and strength of color while chastening it by various means. No painter before him had dared to apply a straight chrome yellow to a large area of the canvas, as he did in Arles. For a similar dras-tic coloring we must turn to primitive art or to the illuminators of the early Middle Ages. Van Gogh's color does not strike us as primitive, however. It has inherited the intervening development of color har-mony, the modulation through light and shadow and value painting, the practice

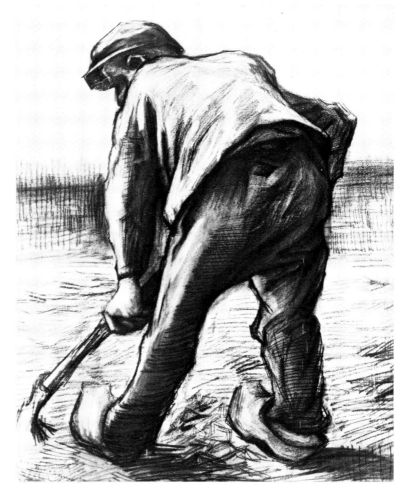

A PEASANT DIGGING *National Museum Vincent van Gogh, Amsterdam*

of mixtures or breaking of tones. There is no work of van Gogh which is so elementary in color as not to show many traces of this more learned, nuanced method. His most intense colors are elements in a scale of inten-sities. Instead of working with pure colors alone, as did many primitives, he operates with variations of purity and thus gives to the quality of intensity a struggling, emergent, climactic character. In *L'Arlésienne* (page 89), the absoluteness of the yellow background is contrasted with the dull flesh color, with the dark-ness of the green table, and with the yellow of the book, which is somewhat lighter, less strongly infused with its own hue. In the *Sunflowers* (page 69), the most saturated pure yellow is an end term in a series of brilliant yellows, some lighter, some darker, some more orange or greenish. This range of saturations is the specifically modern sense of his color; to miss it is to lose sight of a basic character. The primitives' intense color appears to us schematic, restricted, like an instrument with only four or five notes, often very strong in its simplicity, but limited in expression, without dramatic development and culmination. In van Gogh, on the other hand, the absoluteness of a color is felt as a goal, an ultimate point in the gradation of qualities—like the advancing object on the picture plane in a deep perspective—and is therefore the aptest carrier of his own passionateness and vitality. The primitive does not appreciate yellow as a region of color with a great span between opposite poles of brightness and pallor; it is an unmodulated quality for him, an isolated point. He knows only one red, one yellow, one blue, so that the particular tint or intensity

represents that color in general, universally. Western art had discovered the possibilities of color as a dimension or set of dimensions, only by eliminating the extreme saturated tones and by dividing up the intervals of value and hue, that is, by submitting the extremes to the tempering effects of atmosphere and low illuminations. What van Gogh did was to restore the absolute pole, in itself too crude and barbaric for civilized eyes, but to treat it as a final term in a series. This was a search for an ultimate, a highly civilized venture—and for him a spiritual necessity.

This supremely vital art was interrupted by attacks of insanity. Van Gogh was confined at first in the hospital in Arles and, some months later, in an asylum at Saint-Rémy, twelve miles away. The precise nature of his illness is uncertain; recent medical studies tend to the view that it was an "epileptic process" rather than schizophrenia, as was once supposed. Between the recurrent attacks, he was able to paint, and during that period of alternating crises and recovery, he produced some of his greatest works. They are not of the same character as the paintings of his year in Arles, but have often an aspect of strained intensity, which one might connect with his condition.

Restricting ourselves to what we learn directly from the letters of that time and the paintings themselves, we may say that if these have been influenced by van Gogh's state of mind, they belong not so much to his illness as to his depressed mood during the intervals of sanity; but they show also his effort to maintain himself and to forestall new breakdowns by working courageously as an artist, creating new outlets for his feelings, and resisting passivity, melancholy and religious fancies by seeking within his art and his own past all possible sources of strength and hope.

FORTIFICATIONS, PARIS
National Museum Vincent van Gogh, Amsterdam

VAN GOGH'S HOUSE IN ARLES *National Museum Vincent van Gogh, Amsterdam*

During that year at Saint-Rémy, he was drawn especially to objects in strain: to landscapes, unstable, obstructed, and convulsed; to a cataclysmic world of stormy movements and upheavals, nature suffering or disturbed; to great sloping mountains, tumultuous hills and rocks, and fields descending like a rapid stream; to gigantic clouds with coiling, bulging, restless shapes (page 109); to the wild spaces of thick under-growth, ravines, and quarries; to rain; to agitated trees—writhing, flaming cypresses sharply silhouetted against the sky (frontispiece), trees bent, tilted, tormented, with tossing masses of foliage and broken branches, trees crossed in an X (a motif discovered already by Delacroix for his *Jacob Wrestling with the Angel*), olive trees with irregular, jerky, striving limbs (page 107), plane trees raising their branches like gesticulating arms in a street torn up by pavers (page 113), and a tree mutilated by lightning, which recalls the words of Jonathan Swift, who, on seeing a tree that had been struck, said in anticipation of his own madness, "I shall die at the top." In contrast to these, but emanating also from Vincent's disturbed mood in moments of depression, are vast fields with a large sun and a solitary worker, and scenes of a quiet sadness, empty and passive and most distant from the turbulent pictures, but still personal, the paintings of little creatures: rabbits, insects, butterflies, a death's head moth—tiny, fragile forms of animal life, significant for his mood and his musings on life and death.

His own descriptions give us the meaning very well. On *The Ravine:* ". . . two masses of mighty solid rock between which flows a thin stream of water, and at the end of the ravine a third mountain, which blocks it. Such subjects have a fine melancholy, and moreover it's fun working in rather savage places, where one has to wedge the easel in between the stones to prevent everything being blown over by the wind." He wishes to confront his condition and to fight it.

And most moving of all, his magnificent account of the picture of the garden of the asylum: ". . . the nearest tree is merely a large trunk which has been struck by lightning and then sawn off. But a side-branch shoots up very high and then tumbles down in an avalanche of dark green pine needles. This sombre giant, proud in his distress, is contrasted—to treat them as living beings—with the pallid smile of a last rose on the fading bush right opposite him. Beneath the trees are empty stone seats, gloomy box-trees, and a reflection of the sky—yellow—in a puddle left after the rain-storm. A sunbeam, the last ray of light, raises the deep ochre almost to orange. Here and there small black figures wander about among the tree trunks.

"You will realize that this combination of red-ochre, green saddened by grey, and the use of heavy black outlines produces something of the sensation of anguish, the so-called *noir-rouge*, from which certain of my companions in misfortune frequently suffer. Moreover the effect of the great tree struck down by lightning and the sickly greeny pink smile of the last flower of autumn merely serve to heighten this idea."

With the new pathos of the world he pictures, the style of his painting changes. The works from Saint-Rémy are as intense as those of Arles, but the means of intensity have shifted from the colors to the forms, more precisely, to the movement of forms, which become active almost to the point of paroxysmal release.

The brush-strokes, always powerful in van Gogh, are now a torrent or avalanche, a bursting stream of parallel touches, larger than in the past, sweeping through the entire canvas with a wonderful turbulence, in clearly determined paths. The whole is explosive and unconstrained, as if the outcome of a single overwhelming impulse. The agitation of the brush-strokes is more pronounced than in any previous European art; it is extreme like the color of the Arles period, which has another sense—an ecstasy of enthusiasm and love; here, an anguished release.

The color is still a powerful source of expression, although no longer the major force. There are few works with great areas of pure yellow or contrasts of bright complementaries, as in Arles. The color is

HOUSES AT LES SAINTES-MARIES

National Museum Vincent van Gogh, Amsterdam

24

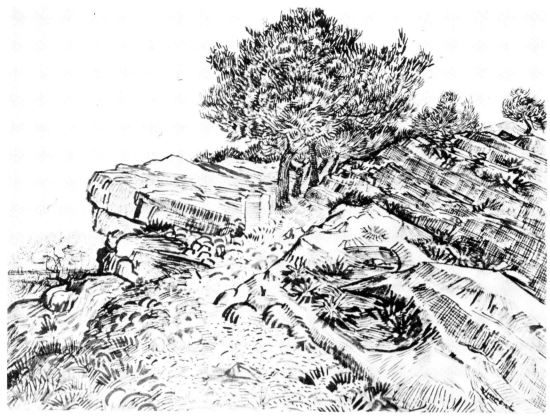

THE ROCK

more tempered, and with all its modernity has something of the air of the old masters in the precise harmony of the low-keyed schemes. Many paintings of this time are in a single basic hue, or prevailing tonality— like the blue of *The Starry Night* (page 101), the orange-yellow of *The Road-Menders* (page 113), the yellow-brownness of the *Fir Woods at Sunset*, the sombre metallic tones of the *Ravine*—a colour or tonality which admits many nuances, neutralizing touches and greys, deepening and enriching the mood.

Van Gogh had painted in a single key in Arles, but there his favored color-motif was the bright yellow of the *Sunflowers* (page 69). In Saint-Rémy, these were replaced by the *Olive Orchard* (page 107), which he described as "old silver, sometimes more blue, sometimes greenish, bronzed, whitening", an elusive, difficult coloring with which he struggled passionately, as if it were a piece of himself. The new palette is no return to the tonal painting of his Holland days, which was built on light and shadow and the traditional atmosphere of brown; it retains the chromatic variety discovered in Paris and Arles, and adds to it a range of rare, broken tones, congenial with his mood. In copying engravings after Millet, Vincent improvised a coloring of sad colds greys (*The Plough*) or tender, whitened blues and greens (*The First Step*).

The minor keys do not determine all the works from Saint-Rémy. Among them are paintings in more luminous and jewelled tones (page 111). But here, too, the color is less decided in expression, less vehement than the brushwork and the lines. It is as if the energy of color and the energy of line in his painting were together a limit of total force; what is added to one must be taken from the other. The objects have lost their self-sufficient stable form; they yearn and strive and struggle with forces beyond themselves, or with internal forces from which they need release. Their color is fractioned, troubled, dimmed; part of their

25

energy of color is converted into energy of line. The contours are prolonged and become increasingly active, winding and twisting as if to attain a maximum surface span. They draw to themselves the whole substance of the object, which is now formed of streaming particles that follow the movement of the bounding lines. In the *Road with Cypresses* (frontispiece) every leaf and branch participates in the upward striving of the edge.

Vincent in Saint-Rémy is inordinately sensitive to movement; he seems to over-estimate the changing directions of the forms of things around him, and to see them as actual motions of the objects. It is as if vision stimulated motor tendencies within him which in turn affected his rendering of the forms.

In the works at Saint-Rémy and later at Auvers, we discern two main kinds of linear forms which are not altogether new in his painting, but are now developed to their highest intensity. They are the continuous, coiling, wavy forms, and the complicated networks of sharply angular and jagged, diagonal lines.

A taste for the curvilinear appeared already in Arles, although confined to minor details. In the summer of 1888, the angular V of his signature became a rounded, vase-like shape (page 69). He was attracted then by bits of curved ornament in the objects he painted, as on the uniform of his zouave friend (page 63), the boats at Les Saintes-Maries (page 57), later the wallpaper in the picture of Madame Roulin (page 95) and the doctor at Arles. These modest elements of curvature, the first intimations of his more powerful coiling forms, were perhaps inspired by Japanese art. But the new work of his Parisian friends, Gauguin and Bernard, and possibly Lautrec, had some effect here too. In the painting *A Walk in Arles*—one of the rare pictures in which van Gogh tried to imitate the new style of his friends—the roadway and the plants are exceptionally sinuous in outline.

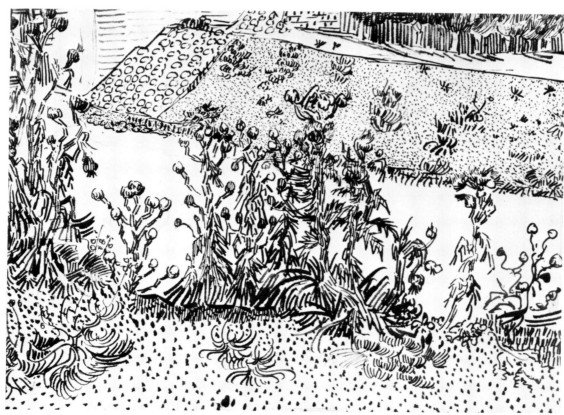

A GARDEN WITH THISTLES

National Museum Vincent van Gogh, Amsterdam

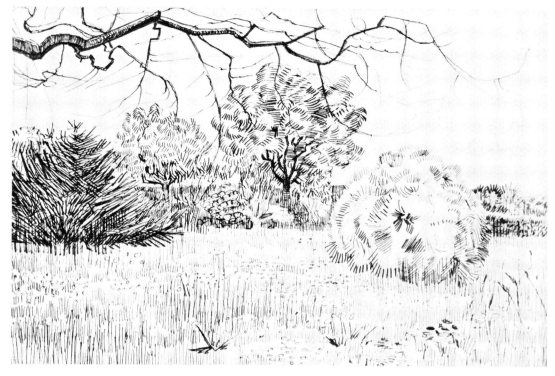

THE MEADOW *National Museum Vincent van Gogh, Amsterdam*

The curved forms at Saint-Rémy might have grown out of these traces, but they have another character; more varied, diffuse, and impulsive, and more highly charged, they are exceedingly dynamic elements, intensifying the whole picture, while the earlier curved forms are only secondary details—surface enrichments and digressions—which sometimes reduce the power of the work by multiplying playful contrasts from point to point, or by resolving a contour into small repeated parts. In Saint-Rémy, the curves are essential elements of a style of high excitation and strain.

It is only on the smallest scale, in the repeated brush-strokes, that van Gogh's execution appears ornamental; but these strokes unite to form a large shape, a curve of a higher, more individualized order, which is rarely repeated in a decorative way, but contributes instead to the turbulence of the whole. In Gauguin, we often find an obvious ornamental repetition of large elements.

The paintings from Saint-Rémy are on the whole less flattened than those of Arles. The modeling of the later works is often much more powerful. There is nothing from Arles like the great trees of *The Road-Menders* (page 113), or the bulky clouds of the same period (page 111).

The other form important for the new style at Saint-Rémy—the network of crossing diagonal lines—had existed in van Gogh's art from the beginning, although little used. In the powerful pattern of the trees in *The Road-Menders* (page 113) and the *Fir Woods at Sundown*, which creates a complex movement and an obstacle in space, breaking up the background irregularly, and determining zigzag lines across the canvas, we recognize a continuity with his art in Holland and Arles. It is an intensification of the similar network in the *Fishing Boats on the Beach at Saintes-Maries* (page 57), *The Bridge at Trinquetaille* (page 77) and *The Chair and Pipe* (page 91). In these the motif is less accentuated, and has little of the pathos of the later works. They were preceded by drawings in Holland with similar forms (page 11), the intricate branchings

of trees and the crossing of various elements of a landscape (page 12). It is remarkable that this original taste was confined for several years to the drawings, and then admitted to painting in a relatively clarified and mild form, to emerge as a means of powerful expression only towards the end, in a style of overwhelming strain. It might have served van Gogh from the first, however, as a release of feelings which were repressed in the paintings by his deliberate concentration on the peasant theme.

His decision to be a peasant painter was itself an attempt to master the difficulties of his person; it excluded the excitement, the complexities and passionateness which were sources of anguish to him. How such intricate patterns felt to van Gogh he has told in his description of a scene in Antwerp: ". . . more tangled and fantastic than a thorn hedge, so confused that one finds

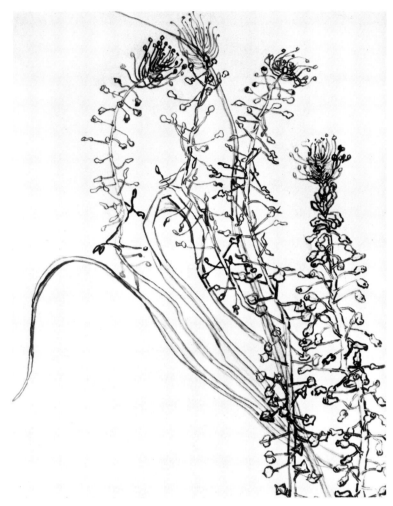

FLOWERING STEMS

National Museum Vincent van Gogh, Amsterdam

no rest for the eye and gets giddy, is forced by the whirling of colors and lines to look first here, then there, without it being possible to distinguish one thing from another." The unstable forms were a world of conflict and stress—the typical patterns of the self in its entanglement and wild impulsiveness. To them he opposed the object—the simple, closed, subsistent thing which one cultivated and controlled; or the human being, most rooted and selfpossessed—the peasant. The developing process of his art may be described as the outcome of a perpetual struggle between these two aspects of his nature, each felt with great poignancy. In Arles where the object triumphed, he gave to it that wonderful intensity which issued from the depth of his desire for security and love.

In Saint-Rémy, more disturbed and conscious of his weakness, his approach to the object was involved in anxiety and despair. It is as if in his suffering, extreme condition, he found it healthier to release these feelings in the controlled forms of painting than to repress them, for they would emerge then in even more disturbing, uncontrollable fancies and hallucinations. At Auvers, he continued to struggle with these alternatives, which sometimes appear in the same work in the surprising juxtaposition of firmly realistic forms and restless arabesques, as in the *Portrait of Dr. Gachet* (page 121) and himself (page 119).

At all times, the network pattern was associated with an original taste for strong diagonals in perspective, with opposed paths or goals; these gave a high tension to the observer's relation to the depth. In several works painted in Arles, two divergent roads form a sharp V, of which the diagonals receding from the foreground are joined to a network of other lines. The effect is almost dizzying in its complexity of competing directions, a web to fascinate and obstruct the eye.

In his use of perspective, van Gogh was an original mind, although other artists, notably Munch, arrived at a similar view. Perspective has so long been despised as a device of photographic imitation that artists have forgotten its expressive and constructive side. For van Gogh perspective was a dramatic element in vision, the carrier of infinity, a means of intensifying a movement into depth. "The peculiar effects of perspective intrigue me more than human intrigues", he wrote early in his studies. From the very first, while struggling with the rules of perspective, he produced drawings of which the beauty lies in the flight of perspective lines and the dynamics of a long vista. While Cézanne, a more contemplative spirit, reduced the intensity of perspective, blunting the convergence of parallel lines in depth, setting the solid objects back from the picture plane, and bringing distant objects nearer, van Gogh, by a contrary process, hastens the convergence, exaggerating the extremities in space, from the emphatic foreground to the immensely enlarged horizon with its infinitesimal detail. He thereby gives to the perspective a quality of compulsion and pathos, as if driven by anxiety to achieve the most rapid contact with the world. This perspective pattern was of the utmost importance to van Gogh, one of his main preoccupations as an artist. Linear perspective was for him no impersonal set of rules, but something as real as the objects themselves, a quality of the landscape

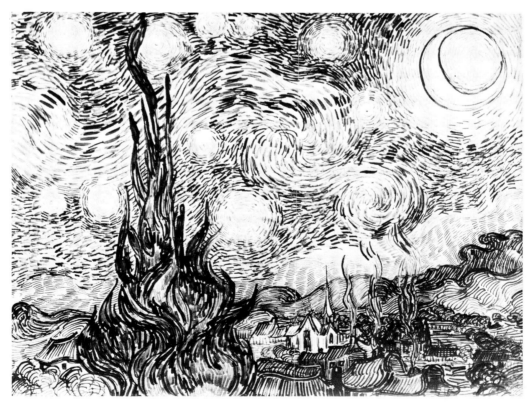

STARRY NIGHT Photo, Museum of Modern Art *Kunsthalle Bremen*

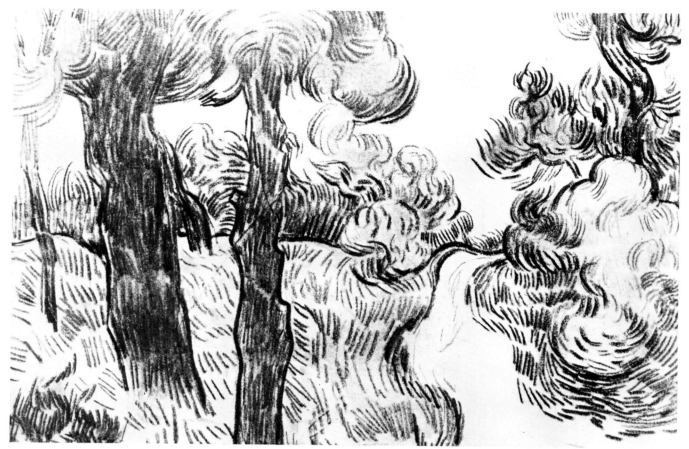

A PATH IN THE PINES

that he was sighting. This paradoxical device—both phenomenon and system—at the same time deformed things and made them look more real; it fastened the artist's eye more slavishly to appearances, but also brought him more actively into play in the world. While in Renaissance pictures it was a means of con- structing an objective space complete in itself and distinct from the beholder, even though organized with respect to his eye, like the space of a stage, in many of van Gogh's first landscape drawings the world seems to emanate from his eye in a gigantic discharge with a continuous motion of rapidly converging lines. He wrote of one of his early drawings: "The lines of the roofs and gutters shoot away in the distance like arrows from a bow; they are drawn without hesitation."

In his later work, this flight to a goal is rarely unobstructed or fulfilled; there are most often counter-goals, diversions. In the *Landscape with Ploughed Fields* (page 115), the furrows carry us to a distant clump of bushes, shapeless and disturbed; on the right is the vast sun, with its concentric radiant lines. Here there are two competing centres or central forms, one, subjective, with the vanishing-point, the projection of the artist not only as a focusing eye, but also as a creature of longing within this world; the other, more external, object-like, off to the side, but no less charged with feeling. They belong together, like a powerful desire and its fulfilment; yet they do not and cannot coincide. Each has its characteristic mobility, the one self- contained, but expansive, overflowing, radiating its inexhaustible qualities, the other pointed intently to an unavailable goal.

In the *Crows over the Wheat Field* (page 131), these centres have fallen apart. The converging lines have become diverging paths which make impossible the focused movement towards the horizon, and the great shining sun has broken up into a dark scattered mass without a centre—the black crows which advance from the horizon towards the foreground, reversing in their approach the spectator's normal passage to the distance; he is, so to speak, their focus, their vanishing-point. In their zigzag lines, they approximate with increasing evidence the unstable wavy form of the three roads, uniting in one transverse movement the contrary directions of the human paths and the symbols of death.

If the birds become larger as they come near, the triangular fields, without distortion of perspective, rapidly enlarge as they recede. Thus the crows are beheld in a true visual perspective, which coincides with their emotional enlargement as approaching objects of anxiety; and as a moving series they embody the perspective of time, the growing imminence of the next moment. But the stable, familiar earth, interlocked with the paths, seems to resist perspective control. The artist's will is confused, the world moves towards him, he cannot move towards the world. It is as if he felt himself completely blocked, but also saw an ominous fate approaching. The painter-spectator has become the object, anguished and divided, of the oncoming crows, whose zigzag form, we have seen, recurs in the diverging lines of the three roads.

* * * *

This taste for deep vistas and dramatically converging or diverging paths seems to contradict another equally striking aspect of van Gogh's art: his surface style, with the bold patterning of the color on the picture-plane, the modern tendency to bring everything to the surface of the canvas. However hard we try, we cannot see the forms of the long perspectives as if they lay upon the canvas surface. We are drawn by them irresistibly into depth.

Yet they are not altogether opposed. Common to them is a conception of space as something lived intensely. For van Gogh both nearness and remoteness are stirring qualities. And his impulse is to give them both a live expression. Hence the object as a part or extension of ourselves is extremely close to us, and sometimes appears magnified, although not really enlarged, because it fills the canvas and projects towards us on the picture-plane; the solidity of the pigmentation increases this effect. Correspondingly, distance is a genuine effect, mysteriously involved in compulsive feelings of longing or flight; this distant world is dynamized by an active movement towards the horizon, as pronounced as the projection towards us of tangible objects.

To modern artists, these perspective schemes, these angular networks and coiling lines, appeal as abstract forms—pure expressions vested in the shapes as such, without regard to the world they represent. Van Gogh was aware of this possibility, which had been formulated in theory by his friends in Paris before it was realized in art; he sometimes employed the word "abstraction" for his use of simplified flattened forms, but also for any painting from imagination. He knew what power of evocation lay in the painter's medium, and spoke of his art as a consoling music of color and strokes and lines. But he could not accept this direction as the best one, although a later generation was to build upon it an art of imageless painting.

He felt himself to be close to the great realistic writers and often avowed in his letters a permanent attachment to the object, his personal credo of realism. This does not mean realism in the repugnant narrow sense that it has acquired today through the polemics of anti-realist critics, and that is too lightly called photographic—photography has also a deeper poetic side in its fascinating revelation of things—but rather the sentiment that the world around us is an object of strong desire or need, as a potential means of fulfilment of the striving human being, and is therefore also the necessary theme of art. When van Gogh describes his paintings, he names the objects and their local colors as inseparable substances and properties. The object was the symbol and guarantee of sanity. He speaks somewhere of the "reassuring, familiar look of things"; and in another letter: "Personally, I love things that are real, things that are possible . . . I'm terrified of getting away from the possible . . ." The strong dark lines that he draws around trees, houses, and faces, like their intense colors, establish their existence and peculiarity with a conviction unknown to previous art. The loading of the pigment is in part a reflex of this attitude, a drastic effort to preserve in the image of things their tangible matter and to create something equally solid and concrete on the canvas. That is why, standing before the ominous sky and wheat field, with the oncoming crows, he is able to paint not only his sadness and solitude, but also, as he wrote, the health and comfort that reality alone can give him. "You will see it soon, I hope . . . these canvases will tell you what I cannot say in words, what I find healthful and strengthening in the country."

When the self at the edge of destruction holds on to objects so persistently, its protective reaction permits us to see that the painter's attachment to things is not passive or conventional, nor due simply to his origin in a period of naturalistic art, but is a constructive function with deep emotional roots. When he comes as a foreigner to Arles, a strange town, he paints everything—day and night scenes, people, children, a whole family, houses, cafés, streets, his own room, and the surrounding country—as if to enter completely into this new milieu, unlike an Impressionist, who in painting at a resort or country site gives us little sense of material things and people. He needs objectivity, the most humble and obvious kind, as others need angels and God or pure forms; friendly faces, the unproblematic things he sees about him, the flowers and roads and fields, his shoes, his chair and hat and pipe, the utensils on his table, are his personal objects, which come forward and address him. Extensions of his being, they image the qualities and conditions necessary for his health of mind. We may quote here what he said in another context: "It sounds rather crude, but it is perfectly true: the feeling for the things themselves, for reality, is more important than the feeling for pictures; at least it is more fertile and vital."

We understand then why he called imaginative painting "abstraction", although it was still an imagery of living forms, and why, on the other hand, the *Crows over the Wheat Field*, for all its abstractness of composition, represents with a tormented veracity an experienced landscape.

During that year in Saint-Rémy, he lived much in memory. His mind returned often to the world of the Dutch peasants and his family and childhood. He could no longer paint these scenes from life, and therefore made many copies after reproductions of Millet and other artists, who had represented the objects that now filled his thoughts. This was Reality and yet a living in the imagination and through art, but it

was an imagining of real things in their most vivid presence, not a supernatural or impossible world. Copying the Millets, he said, was for him like the musician's performance of another composer, interpreting and improvising the color from the black and white engraving.

Among his copies are some religious themes, after Delacroix (pages 105 and 117) and Rembrandt. Their subject matter tells us van Gogh's story and longing for salvation; in the *Pietà*, Christ in his mother's arms has a face like Vincent's; and the closed landscape in *The Good Samaritan* with the abandoned victim recalls the great *Ravine* he had painted near Saint-Rémy. The copy after Rembrandt is of the *Raising of Lazarus*, but it is only a section of the original etching—Lazarus and his sisters, with Christ replaced by the sun which had once intoxicated the artist and now appeared often in his moodier, more melancholy works.

These paintings were an answer to a double temptation; for van Gogh was not only disturbed by religious hallucinations, but his friends, Gauguin and Bernard, with whom he identified his art more than with any other contemporaries, were painting religious themes. And Vincent was a deeply receptive man, eager always for friendship and collaboration. But to Bernard's descriptions of his new religious pictures inspired by medieval Christianity, the former theological student and missionary replied that such an attempt in our age was an impossible evasion: "It's an enchanted territory, old man, and one quickly finds oneself up against a wall"; only the reality of our time could provide the ground of art and human satisfaction. But he himself could not survive on this ground. It implied faith in a social order of which he perceived the injustice and cruelty and growing chaos. At this moment already, to artists of insight, "reality" meant for the most part the things that constrain or destroy us. Vincent observed that under modern conditions artists were bound to be somewhat crazy; "perhaps some day everyone will be neurotic". He would not turn to an inner world of fantasy that might console him, since he knew that for himself that surely meant madness. Towards the end, he was drawn at times to religious fancies, but fought them off as unhealthy. The figure of the human Christ still attracted him. If he wrote of God as an artist whose one great creation, the world, was "a study that didn't come off", he revered Christ as the supreme artist, "more of an artist than all the others, disdaining marble and clay and color, working in the living flesh". But the few Christian themes that he painted while in the asylum were, without exception, copied from prints after other artists. and they were significantly images of pathos. His sincerity, requiring always faithfulness to direct experience, kept him from inventing religious pictures. When inspired by the vision of *The Starry Night* (page 101), he put into his painting of the sky the exaltation of his desire for a mystical union and release, but no theology, no allegories of the divine. He had written to Theo some time before, after describing his plan to do difficult scenes from life: "That does not keep me from having a terrible need of—shall I say the word—of religion. Then I go out at night to paint the stars". There is, however, in the coiling nebula and in the strangely luminous crescent—an anomalous complex of moon and sun and earth-shadow, locked in an eclipse—a possible unconscious reminiscence of the apocalyptic theme of the woman in pain of birth, girded with the sun and moon and crowned with the stars, whose newborn child is threatened by the dragon (Revelations 12, 1 ff.). What submerged feelings and memories underlie this work is hinted also by the church

33

spire in the foreground, Northern in its steepness and acuity, a spire which in the earlier drawing (page 29) is lost in the profusion of writhing vertical trees—the monotony of uncontrolled emotion—but is disengaged in the final work where a pictorial intelligence, in clarifying the form, strengthens also the expression of feeling.

In the last two months of his life, in Auvers, the objective spirit is still very strong. Returning to the North, and close once more to Theo and his old friends, van Gogh attempts to assimilate again the village and peasant world he has lost. The crises of the year before, the tragic revelation of his infirmity, had made a glowing, joyous art like his painting at Arles impossible for van Gogh. But he is able to recreate the landscapes and people of Auvers with a new passionateness and harmony in which the wavy, writhing forms of Saint-Rémy are constrained by his inveterate attachment to the real—always fresh to him in its challenging wonder of varied shapes and unexpected tones which take him beyond himself. With his rising and ebbing hopes—for the depression soon returned, a recurrence of the despair of Saint-Rémy, this time more hopeless than before—his work in Auvers passes through an extraordinary wave of stormy feeling. To his old troubles were now added the cares of Theo who had married and had a child to support, at a time when his affairs were insecure. Vincent's thoughts in his letters turn often to his coming end.

In this mood, we are struck in his last works by the frequence of a beautiful deep blue—it appears in the landscapes (page 131) and in the portraits of Dr. Gachet (page 121) and Mademoiselle Ravoux (page 129). In these portraits it is contrasted with the pallor of the nervous faces; in Arles, the subdued face of *L'Arlésienne* (page 89) has for its counterpart the other extreme, an intense yellow ground—a wilful, vaguely pagan note. The blue of Auvers is not a flat even color, like the blues of Arles, which he had once likened to infinity in describing the imaginary portrait of an artist-friend, but a more suggestive, mysterious, pulsing or flickering void. There is in these dark blues of Auvers, and especially in the painting of the *Crows* (page 131), something of the mood of *The Starry Night* (page 101). After we have seen in the latter its startling, transfigured sky and have felt the pantheistic rapture stirring the immense bluish space with an overpowering turbid emotion, we are prepared to recognize in the latter work the traces of a similar yearning. The endless sky of the *Crows* appears to us then an image of totality, as if responding to an hysterical desire to be swallowed up and to lose the self in a vastness. In the abnormal format there is already a submersion of the will. The prevailing horizontal is a quality of the mood more than of the frame or canvas; it has the distinctness and intensity of the blue and belongs to the deeper levels of the work. It is not required by a multiplicity of panoramic objects or a succession in breadth, but governs the space as an enormous dominant beside which the vertical hardly comes into being and is without an echo in the composition. He is caught up across the yellow fields from the chaos of the paths and the dread of the approaching birds and carried to the deep blue sky, the region of most nuanced sensibility, a pure, all-absorbing essence in which at last subject and object, part and whole, past and present, near and far, can no longer be distinguished.

COLOUR PLATES

Painted May 1884

THE LOOM

Collection State Museum Kröller-Müller, Otterlo, The Netherlands

$$(27\tfrac{5}{8}'' \times 33\tfrac{1}{2}'')$$

THIS is one of a series of studies of weavers at the loom. Van Gogh gave to the image of the worker at the machine a high solemnity and power. In the earnest skilful labour of the weaver, he felt, no doubt, a kinship with his own artistic work. With great dignity, the peasant sits at the loom, which fills the space monumentally with its constructed vertical and horizontal dark forms. The sombreness of the image is not only a search for expression, it is a consequence of van Gogh's love of painting in light and dark shadow in a dominant brown tonality which reduces the intensity of local colours, but in turn gives to the whole a more decided and mysterious effect, as if the intangibles of a mood or spirit prevailed over the substance of material things. Although the forms are in places cut out too sharply against the background, the relationships of light and dark are finely studied and harmonious: observe in particular the cool tones of the cloth in light and shadow beside the warmer background tone, itself cool beside the browness of the loom, and the fine intervals between them. The suspended lamp at the right is beautiful in its greys and in contrast with the lighter wall and the ochre tassel beside it.

Of a drawing of the same subject, Vincent wrote whimsically: "This colossal black thing, which has become so dingy-looking—an old-oak colour—with all its ribs stands out in sharp contrast to its grey surroundings; and in the midst of it sits a black ape or gnome or ghost who makes those ribs clatter all day long."

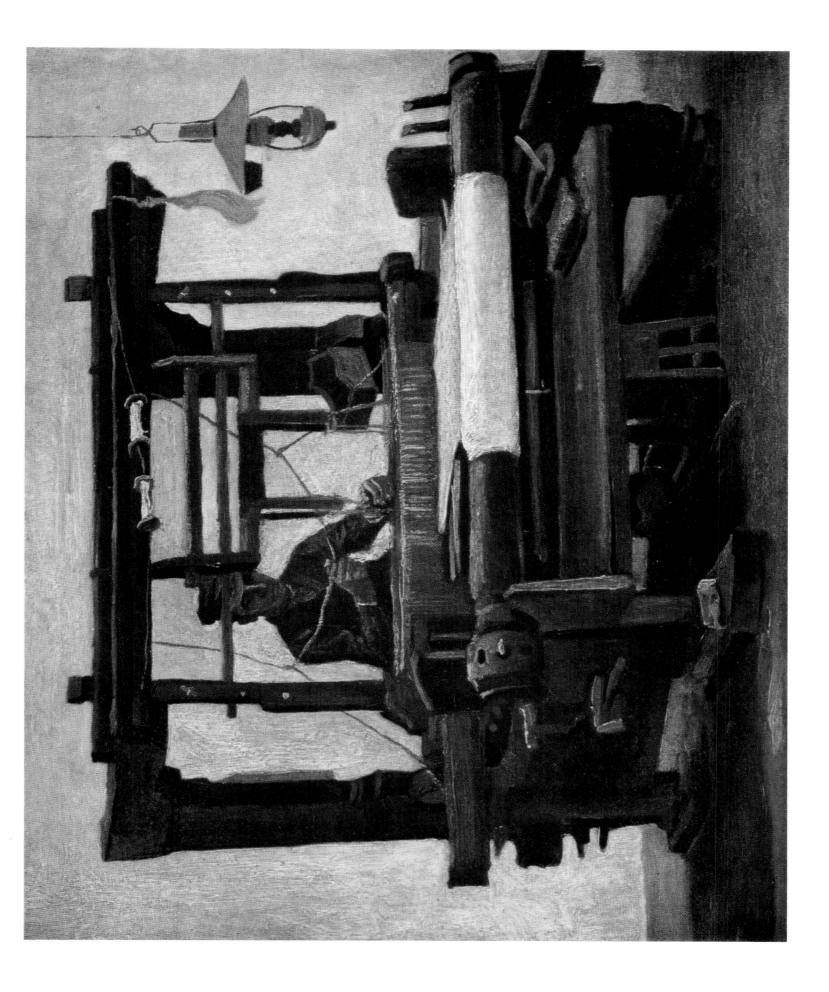

Painted September 1885

STILL LIFE: HAT AND PIPE

Collection State Museum Kröller-Müller, Otterlo, The Netherlands

$$(14\tfrac{1}{8}'' \times 21\tfrac{1}{4}'')$$

B Y the end of 1884, van Gogh had become increasingly interested in the problems of colour. He wished to create a harmonious passage from light to dark without losing the freshness and depth of the local colour of objects, which he had previously submerged in the darkness of shadows and in the prevailing brownness of the whole. The present work is still dominated by the brown of the table and the dark background; in the brighter objects, the warm tones emerge and the greens and blues tend towards neutrality. The objects, distinct in colour, are finely related through common tones in the shadows and by a simple stepping and circulation of the intensities of the local colours, from the pure vermilion touches on the bottle at the left to the brick-red pot and yellow hat, of which the shadows are close to the shadows of the green jug at the right and its cords.

Painted April 1885

THE POTATO-EATERS

National Museum Vincent van Gogh, Amsterdam

$(32\frac{1}{4}'' \times 44\frac{7}{8}'')$

CONCEIVED as a summation of van Gogh's work and study up to that time, it also expresses most strongly and fully his social and moral feelings. He was a painter of peasants, not for the sake of their picturesqueness—although he was moved by their whole aspect—but from a deep affinity and solidarity with poor people, whose lives, like his own, were burdened with care. He found in their common meal the occasion in which their humanity and moral beauty are strikingly revealed; they appear then as a close community, based upon work and the sharing of the fruits of work. The table is their altar and the food a sacrament for each one who has laboured. Under the single light at this common table, the solitude of the individual is overcome and the harshness of nature, too—yet each figure retains a thought of its own and two of them seem to be on the brink of an unspoken loneliness. The colours of the dark interior, blue, green, and brown, bring us back to nature outside. In the homely faces and hands of these peasants— in colour and modelling they are like the potatoes that nourish them—there is a touching purity. It is the purity of familial souls in whom care for one another and the hard struggle with the earth and weather leave little place for self-striving.

The composition has a rough strength, in part the result of a naïve placing. And in van Gogh's clumsiness, which conveys also, as he intended, the clumsiness of his people, there is a source of movement. The grouping of the figures at the sides of the table is odd; the wall between the two figures at the right creates a strange partitioning of the intimate space.

Within the gloom of the dark tonality are remarkable bits of painting, prepared by his tenacious studies: the cups of coffee, with their grey shadows; the potatoes on the platter; and the superb heads, which in their isolation from one another betray the portrait studies from which they were copied. The eyes of the two figures at the left shine with an inner light and the shadows on their features are more a modelling of character than a phenomenon of darkness. "I like so much better to paint the eyes of people than to paint cathedrals", van Gogh wrote shortly after.

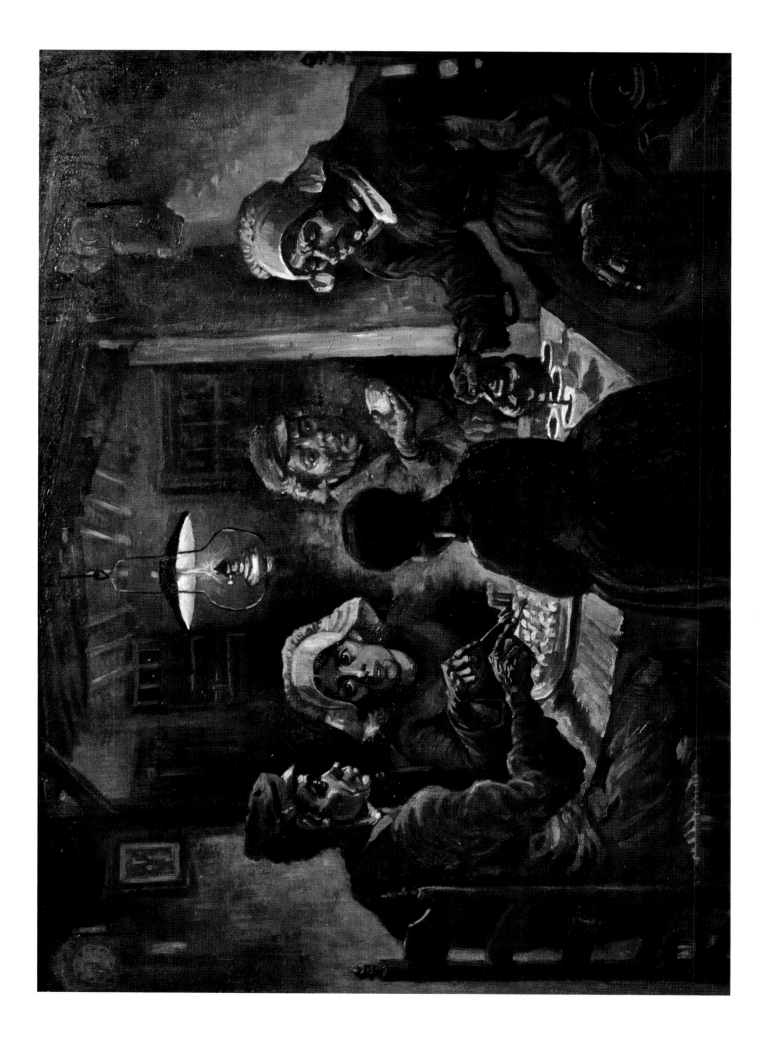

Painted October-December 1886, Paris

MONTMARTRE

The Art Institute of Chicago. Helen Birch Bartlett Memorial Collection

$(17\frac{1}{8}'' \times 13'')$

ONE of the first paintings made by van Gogh in Paris, it shows already his rapid assimilation of French art. It is not yet fully Impressionist, but moves beyond Impressionism and points to the twentieth century in its graphic brushwork and in the search for a delicate atmosphere which belongs not only to the visual but to the feel of a landscape to a spectator with a decided emotional bias in looking. The key greyness, pervading elements so different as sky, earth, and distant city— a vague ocean reaching to the horizon—touches also the colour of the fences and the lamp-posts, and in these varied substances is distinguished by a nuancing of warm and cool as refined as Manet's, a born Parisian. As in the latter's work, scattered touches of colour, here yellow and blue, together with some points of black, punctuate the greyness. But most remarkable is the quality of the greens— indescribably tinged by the greyness—and the purplish reds of the barely suggested, still lifeless trees. The painting of the lamps is a subtle piece of gradation of grey tones. A precisely noted luminosity, almost wintry, is sustained throughout. The brushwork, adapting itself flexibly to the substance and directions of objects, is another source of life. Within this delicate harmony of light grey tones, vaporous and filmy, we are surprised to discover a precise armature in the drawing, in which the reality of things and the less evident reality of the observer's perspective con- stitute a finely rhythmical structure of verticals and diagonals. The irregularities of the fence and the posts, the tiltings and subtle waviness which extends even to the surface of the foreground, are highly realistic and at the same time the discoveries of an emotionally charged vision.

Painted Winter 1887–88, Paris

PERE TANGUY

Collection Stavros S. Niarchos

$(25\frac{5}{8}'' \times 20\frac{1}{8}'')$

AMONG the people van Gogh knew in the art world of Paris, Père Tanguy was closest to his image of simple humanity. This warm, friendly man, devoted to the struggling or unrecognized artists who came to his shop, was a Breton of radical convictions; he had taken part in the Commune of 1871, had been exiled and amnestied, and now sold artists' supplies in a little store which was a centre for the Impressionists and the younger *avant-garde*; there one could see Pissarro, Cézanne, and Gauguin, and also their paintings. Van Gogh made at least three portraits of Tanguy. This one is remarkable for the combination of a naïvely realistic view—the centred, perfectly frontal figure, which reminds us both of medieval art and the primitives of photography—with a complex setting of works of art, mainly Japanese. The idea of the portrait figure among objects of art was common then among artists with a high culture and curiosity; examples are Manet's portrait of Zola and Degas' of the painter Tissot.

With a self-consciousness rare in his portraits, van Gogh paints both his friendship and his love of an exotic art. The surroundings and the figure clash—a gay outdoor colouring in the first, more earnest tones in the second, dark blues and browns of a scale closer to the humanity of the sitter. Yet the whole is a joyous harmony of bright and deep colours. Bold touches of green and red in the face and hands unite the figure to the surroundings; a surprising vermilion line traced freely along the costume repeats the red lines of the background. The diagonal arms, legs, and lapels are symmetrical counterparts of unmarked diagonals implicit in the pairing of similar elements in the Japanese works. Tanguy's homely features and, above all, the eyes, are powerfully done, with a loving search of the qualities of the friend. The face is intensely alive; the man's spirit radiates from a hidden region between the eyes, determining the radiation of the other features and the brush-strokes. An equal life and firmness are transmitted to the tightly joined hands.

The Japanese heads are painted in pale flat tones, faithful to the originals and in polar contrast to Tanguy's face—a clear sign that van Gogh understood an essential difference between Far Eastern and European art, for which man had a deeper meaning.

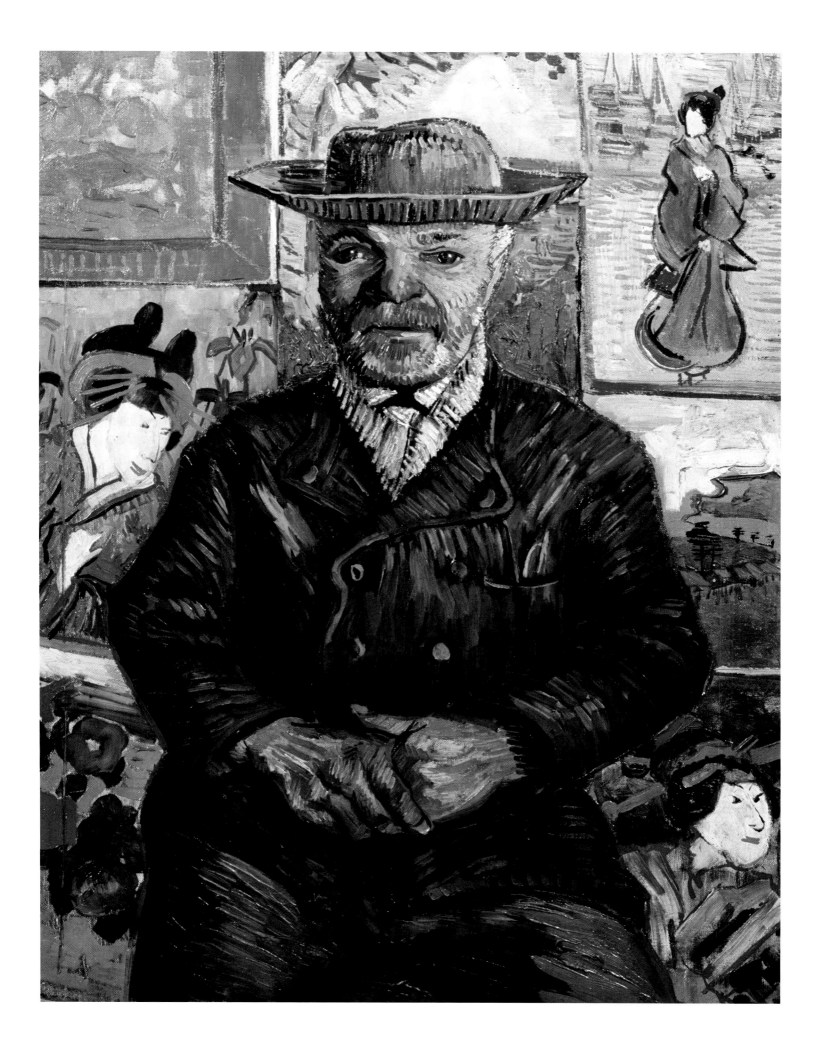

Painted April-June 1887, Paris

A WHEAT FIELD

National Museum Vincent van Gogh, Amsterdam

$$(21\tfrac{1}{4}'' \times 25\tfrac{3}{8}'')$$

A BEAUTIFUL landscape, Impressionist in its outdoor colouring and the woven mixture of the brush-strokes, but above all in the tender, poetic quality of the early summer day, with an airiness that belongs to the wind more than to the atmosphere. The clouds and the slender wheat are blown in the same direction as the flying bird. The simplicity of the division into three bands—sky, wheat, and foreground—would be exceptional in an Impressionist, more disposed to asymmetry and unexpected vistas. Also distinct and in keeping with van Gogh's love of the object-reality is the conception of the stroke as an equivalent of the structure of what he represents; hence the marked difference between the flecking of the sky and the touches that render the wheat, the poppies, and the stubble, each with its own shape and direction, as well as local colour. The execution is rapid and lyrical, completely permeated by the qualities of the scene—a breathing work. Particularly fine are the variations within the broad simple areas of the canvas: in the sky by changes in value alone, by different tones of blue, lighter and darker; in the wheat by passages from cool to warm, yellow-green to blue-green, with minor touches of the red, blue, and white of the field flowers; in the foreground, a warmer prevailing tone of bright yellow, in contrast to the blue sky, includes lavender touches.

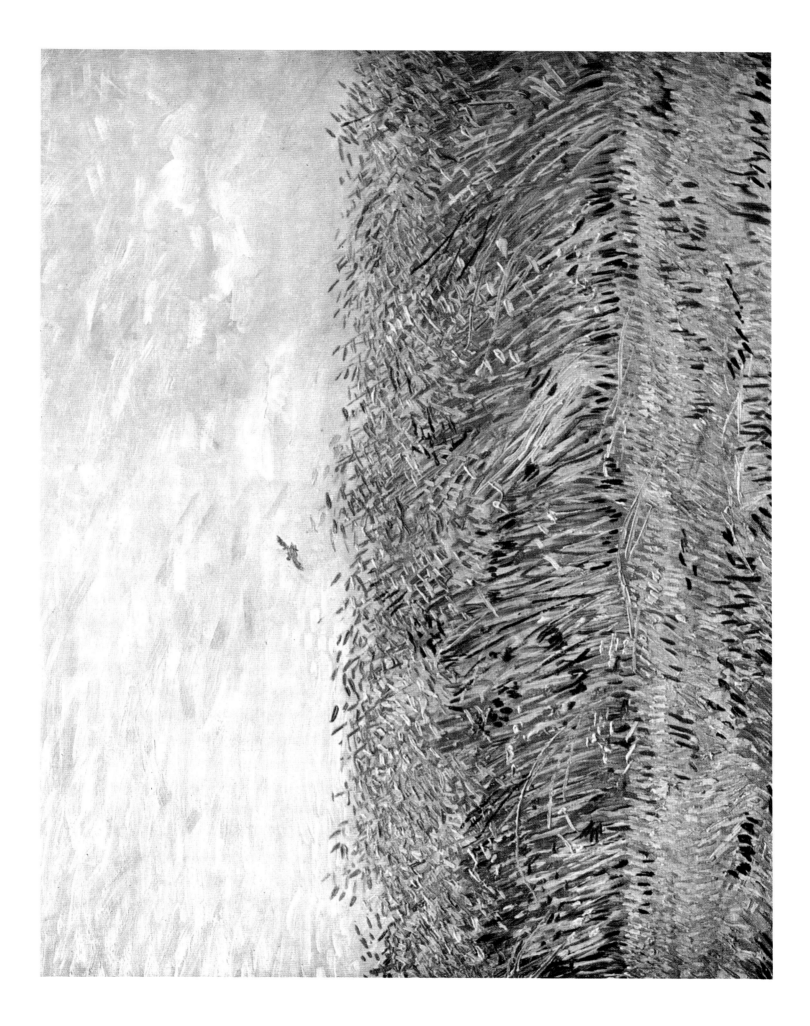

Painted Winter 1887–88, Paris

SELF-PORTRAIT

National Museum Vincent van Gogh, Amsterdam

$(25\frac{5}{8}'' \times 19\frac{7}{8}'')$

WHILE in Paris, van Gogh produced twenty-two portraits in a period of less than two years, twice as many as he was to paint in the next and last two years of his life. Compared to Rembrandt's sixty or more in forty years, van Gogh's repeated self-portrayal is astonishing, and all the more so beside the Impressionist gaiety and outwardness of most of his Paris paintings. Illness and quarrels, and a conflict between the demands of the new art and deeply rooted personal values, important in his earlier and later work, threw him back upon himself. In some of his portraits we see a profoundly earnest, troubled face, searching and struggling for its path.

This one, the last of his Parisian self-portraits, is the masterpiece of the series and a résumé of what he had learned in those two years.

Painted largely in shadow, it is luminous throughout, with its greatest mass of rich colour—the blue—in shadow; the same reds and greens appear in shadows and full light. The greenish tone brings out the intensity of the beard and overcasts the contracted brooding features, the most shadowy region of the work. The contrast of light and shade, like that of red and green, evokes a contrast within the personality, evident in the difference between the two sides of the face—the darker, more depressed side blocked by the high canvas, the lighter, more active and open, dominating its space and surmounting the palette and hand, with their freer play of reds and greens and the two dark cups like the eyes. The major chords of yellow and blue, green and red, interweave and circulate throughout the space in unexpected recurrence—an imaginative use of colour beyond technique or rules. The dosage of tiny, contrasting spots—a lesson of the Neo-Impressionists, applied freely, without doctrinaire spirit—creates a varied surface pattern and accents the forms; the background is treated, with no loss of luminosity, in a more traditional way.

Within the firmly built massive whole is an undercurrent of restless feeling; the powerful diagonals of the palette and brushes, tied to the easel and stretcher, are parts of an irregular network, including the broken diagonals of the smock. All these lines contribute to the expression of the head, which has similar, closely joined, angular forms and looks rounded only against the sharper angularity below.

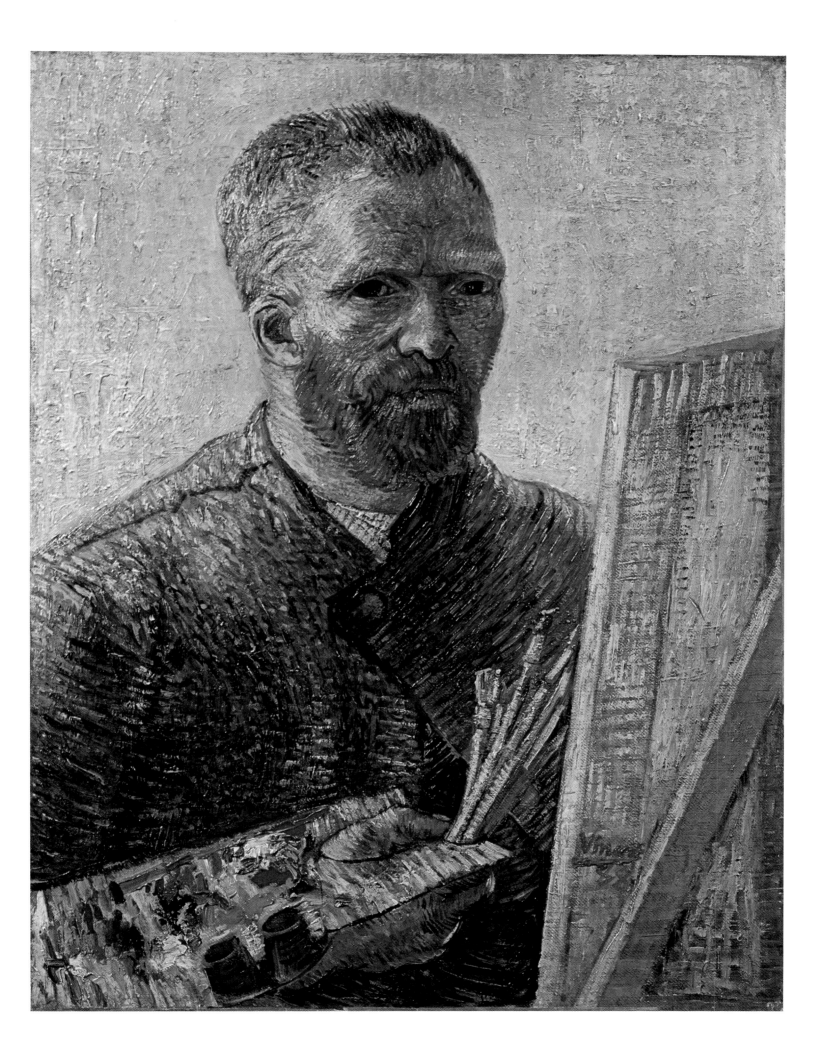

Painted March-April 1888, Arles

THE ORCHARD

National Museum Vincent van Gogh, Amsterdam

$$(25\tfrac{3}{4}'' \times 31\tfrac{7}{8}'')$$

THE orchard in blossom, van Gogh's first welcoming encounter in the South, to which he had come in expectation of a healing, revitalizing nature, was for him an intoxicating vision, and it is this ecstasy that, pervading his work, sets it apart from the familiar Impressionist joy in light and atmospheric colour. The trees raise to the sky a broad mass of immaterial whiteness and pinkness—more a floating emanation than a mass—scattered and suspended in a sky of equally varied tones, and playing against the interspersed phantom leafage and nerve-thin branchings which in places acquire a visionary aspect that recalls both Far Eastern painting and the discreet beauty and tenderness of the distant elements in early Western landscapes. All this intricate upper region of the picture—blossoms, sky, and arboreal network—coalesces into an overpowering pungency and intoxi-cation of the senses in which the observer must lose himself. Without apparent order, an explosion of fragrance radiates and expands, filling its space, like the long horizontal clouds, in vaguely suggested diagonal and vertical directions.

In contrast to the enchanting diffuseness of the upper zone, the lower half of the picture is more solid and stable, with large areas of green and reddish colour and the sturdiness of the irregular tree trunks, whose recurrent blue verticals repeat in colour and oppose in direction the blue bandings of the sky. But here too is a palpitation of feeling realized in the streaking of colour, the reds and the yellows— a streaking which in its deliberate verticality provides a contrast to the upper zone, and yet retains something of the latter's freedom and reverie through the shapeless or unstressed patterning of the areas they form. Uncommitted to the technique of a school, van Gogh's brushwork ranges from these neatly aligned strokes of red to the thick formless patches which convey in a magical undefinable manner the quality of blossoms in the air.

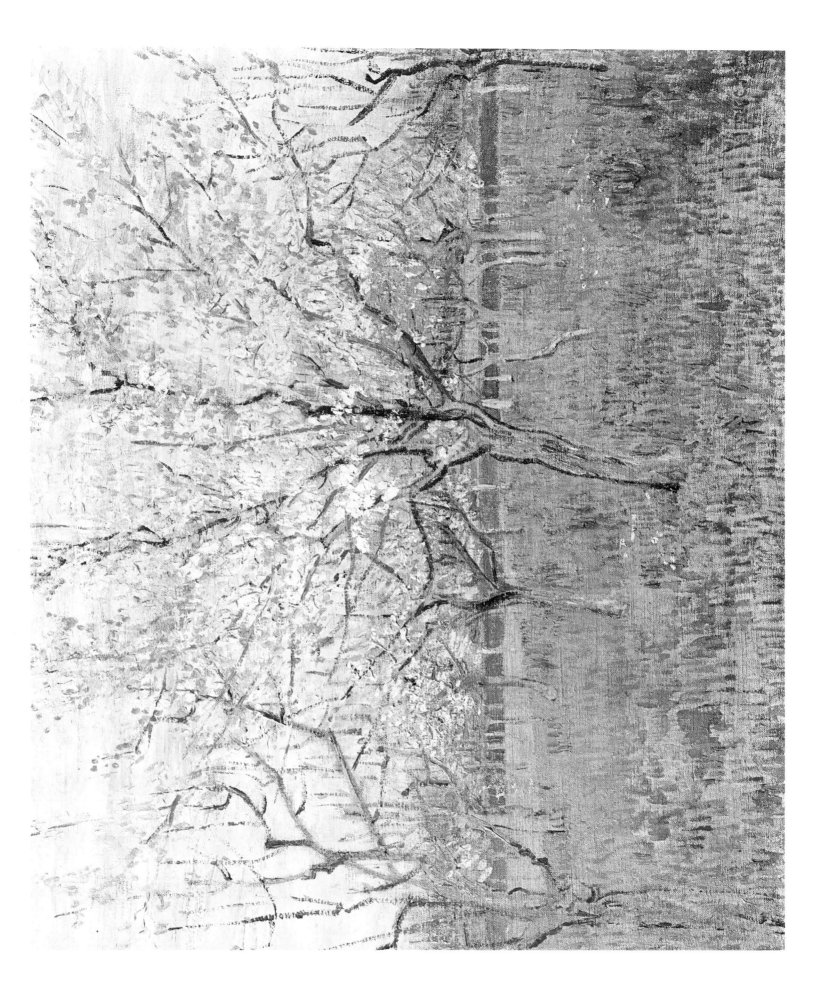

Painted April 1888, Arles

ORCHARD, SPRINGTIME

Private Collection

$$(25\tfrac{1}{2}'' \times 31\tfrac{7}{8}'')$$

IN this, one of the most Impressionist of all van Gogh's works, he attempts to capture not so much a quality of light and atmosphere as of things, things which are, however, the airiest and lightest and most akin to sunlight—the blossoming trees. The orchard is sparse, its blossoms immaterial, and therefore merging with a sky which is itself like the blossoms in the delicate tiny spotting of white and blue. A like spotting colours the ground, a rare soft blend of warm blue and lilac and light yellow tones, like the blend of the blossoms and the cooler sky. Earth and sky seem made of the same transparent substance—tiny particles of pure vibrant colour. The methodical Impressionist touch and division of tones is no strict formula here. The trees are drawn in outline and the beautiful fence in long parallel strokes. The dark inky blue trees in the distance are as delicate and weightless as flowers, yet very precise; the fence, a fine spectral film; the shadows cast by the trees, a joyous striping of gay blues, light and dark. Every object, every division of the ground, has its own peculiarity of colour and touch, while all unite in the common diaphanousness and brightness to exhale an unearthly sweetness and charm.

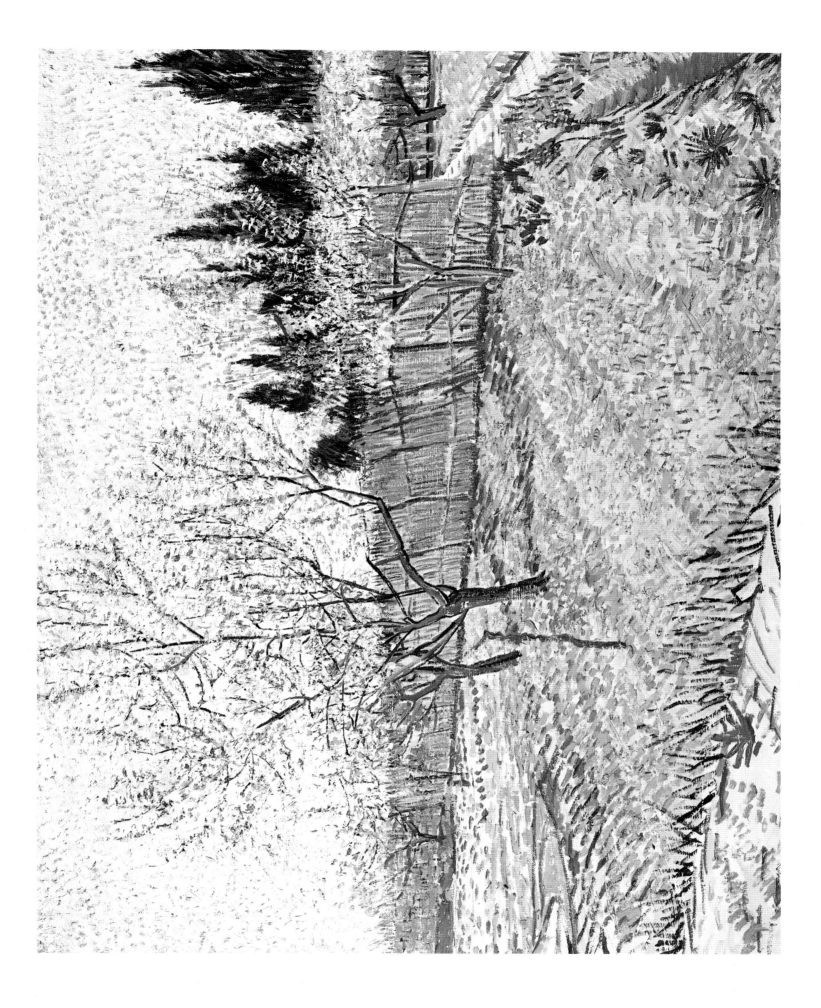

Painted May 1888, Arles

THE DRAWBRIDGE

Wallraf-Richartz Museum, Cologne

$(19\frac{1}{2}'' \times 25\frac{1}{4}'')$

A DELICATE poetic vision that suggests the art of the Far East: dominant sky and water, few objects, little tension and crossing of forms, an approach to a peaceful reverie. A distant cloud is the most solid, tangible object. Aligned in a horizontal band along the horizon is a file of varied objects of an immaterial quality, each one delightful to the eye: houses, blue as the sky, slender cypresses of delicate stroke, an enchanting miniature horse and carriage and rider, the drawbridge, slender and filmy like a spider's web, and, at the extreme right, light blue houses with red-striped rooftops permeated by the light. What a surprise is the inner bluish wall of the stone bridge, transparent like the water below, itself the bridge between the water and the sky!

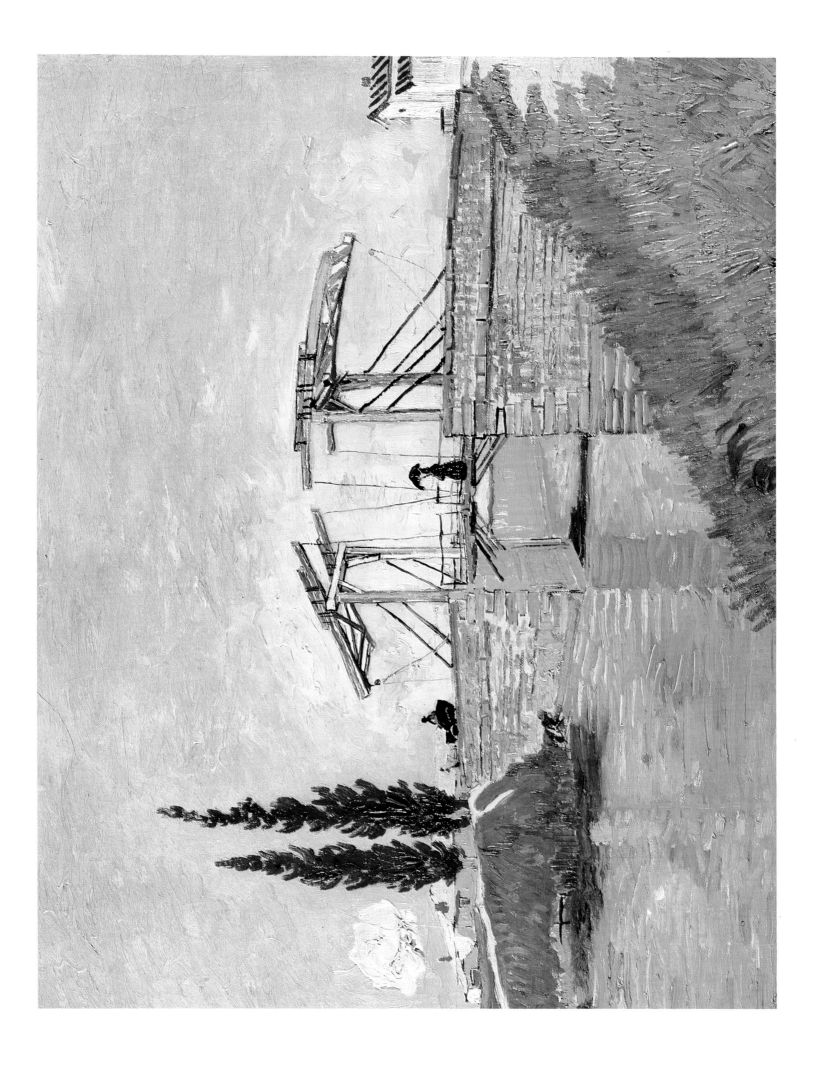

Painted June 1888, Arles

FISHING BOATS ON THE BEACH AT SAINTES-MARIES

National Museum Vincent van Gogh. Amsterdam

$(25\frac{3}{8}'' \times 31\frac{7}{8}'')$

VAN GOGH has described with joy his visit to the Mediterranean shore near Arles at the fishing village of Saintes-Maries, where he painted and drew for several days. It was a new world for him, and he responded to it with his usual eagerness and excitement.

In the picture of the fishing boats, two different kinds of vision are united in one work: nature seen as light and airy, in countless tones of high-keyed colour, ever changing and vibrant through universal contrast; on the other hand, man's objects, the boats, drawn precisely and painted in flat airless tones of primary colour. The pearly softness of the seascape becomes a setting for the hard, firmly compartmented colours of the boats. But these boats, disposed along the beach beside one another, overlapping and with crossing masts, make an intricate network of spots and coloured lines, which participate in the unstable airy shiftings of the natural tones, in the irregular patterns of the seashore and the waves, and the vast currents of the shapeless clouds. This network of the boats is a typical pattern of van Gogh's vision; it had appeared already in his Dutch period in the drawings of trees, and as in those early works the branchings of the boat are drawn with unflagging devotion to the detailed individual shapes.

As the colour ranges from the frank primary hues of the boats to tones of iridescence in the sky, with delicate blues, greens, and lavenders, and nameless sandy tones, on the beach blendings of cool, neutralized yellow, tan, and brown —Impressionist in the subtle discriminations and pairings of cool and warm—so in the application of the paint, there is a corresponding span from thin, flecked, and transparent touches to thick and mat.

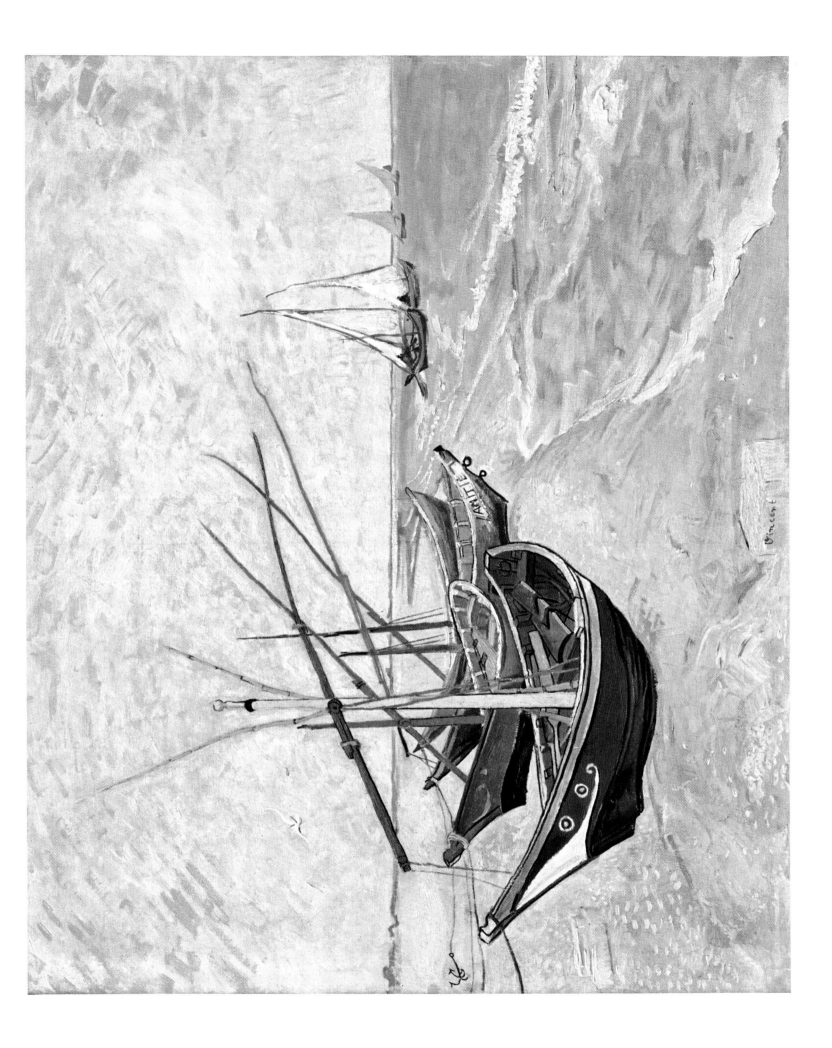

Painted July 1888, Arles

"LA MOUSME"

National Gallery of Art, Washington, D.C. Chester Dale Collection

$$(28\tfrac{7}{8}'' \times 23\tfrac{3}{4}'')$$

A MOST sympathetic portrait in which van Gogh has tried to combine the subtlest painting of nuanced tones in atmosphere and light with his new joyous sentiment of pure colour and large, strong contrasts. The first quality we see in the delicate modelling of the face, with little touches of warm and cool tones, with almost imperceptible differences, as in the painting of the upper lip against the surrounding skin, the whole suggesting by its soft transitions and pallor a corres-ponding feminine quality. The light background toned with a delicately emergent greenness belongs to the same family of colour. Against these rare phantom tones sing the intense, abundant stripes and spots of orange, blue, and red, in the costume of the girl. Beautiful are the tempering, more neutral colours of the arches of the chair—the dark pole of the background colour. The chair together with the hands break up the immensity of the spotted skirt into striking areas whose rhythm continues into the light green area in the lower right—a subdivision in sharpest contrast to the simplicity of the upper body, yet tied to the latter through the curved and alternating stripes of the bodice. The silhouette, as always with van Gogh, is vigorous and interestingly contrived. Many fine little touches of colour show his alertness as a composer: the bit of blue on the collar, the dark violet and greenish tones in the hair, the blue strokes in the left eye and between the lips, the ochres in the ear and jaw, the long curved file of modelled orange buttons which rise from the ornamental flat orange spots below, and, isolated against the cool greenish background, the dainty bizarre ends of red ribbon.

Of the subject, van Gogh wrote to his brother: "If you know what a 'mousmé' is (you will know when you have read Loti's *Madame Chrysanthème*), I have just painted one . . . A 'mousmé' is a Japanese girl—Provençal in this case—12 to 14 years old . . ."

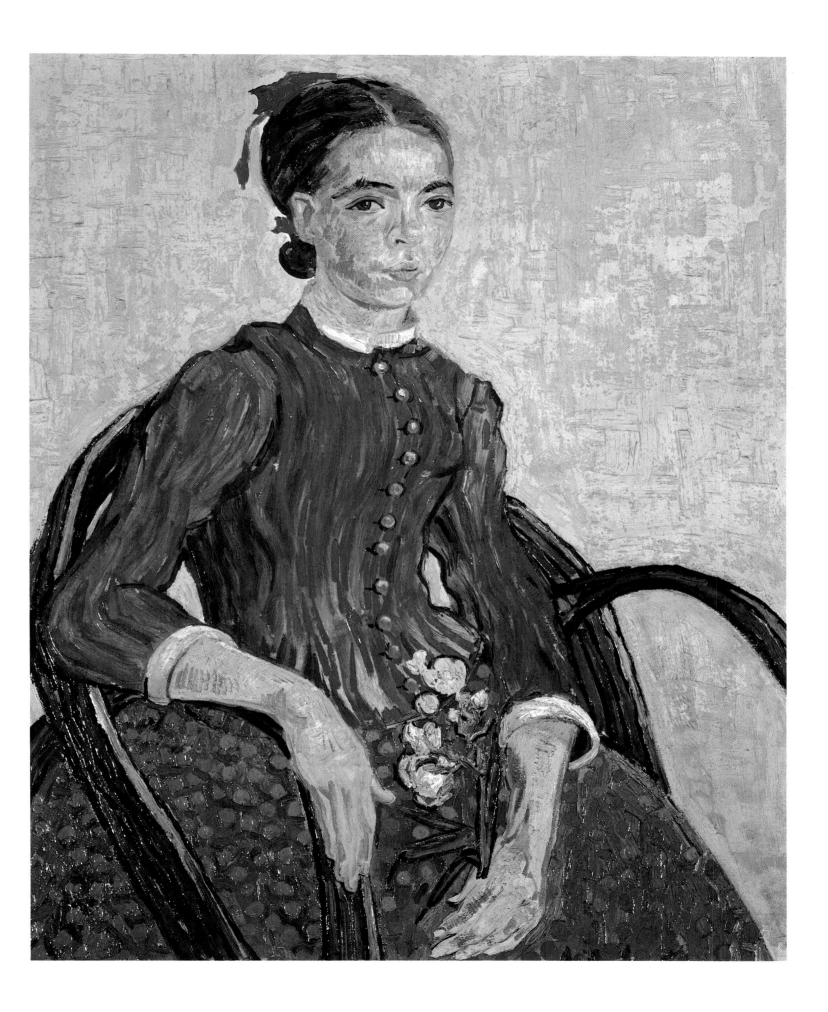

Painted July 1888, Arles

THE POSTMAN ROULIN

Museum of Fine Arts, Boston. Gift of Robert T. Paine, II

$$(31\tfrac{7}{8}'' \times 25\tfrac{5}{8}'')$$

V AN G OGH, always drawn to people, made friends with Roulin, a postman in Arles, and painted him several times, as well as his wife and children. Van Gogh, who loved his Socratic person, has described his candour, intelligence, and enthusiasm, his "silent gravity and tenderness"; "his voice has a strangely pure and touching quality in which there was for my ear at once a sweet and mournful cradle-song, and a kind of far away echo of the trumpet of revolutionary France."

The blue uniform sets the major tone of the portrait, but Roulin's official character cannot subdue his personal quality. In the end the blue becomes an attribute of the man, like his blue eyes (which are also like the gold buttons!). The radiant face, fixed upon us like an icon, is perfectly fresh and unstylized; the broad beard is a landscape, an inverted forest with a profusion of yellows, greens, and browns. The rigidity of the head is tempered by the quivering, raised features and the varied flesh tones. The clumsy hands are awkwardly drawn, but the left remains natural and powerful. The large, almost shadowless, expanse of the blue uniform—a difficult problem for a painter—is paired in one kind of contrast with the light blue background, in another with the warm tones of the head and hands and its own gold buttons and braid, and is converted into a most active, tangible envelopment of a real human body. Attached to the precise reality of the clothes as a worn vestment, van Gogh traces its contours in vigorous black lines, which are applied with discretion—omitted at the shoulder and else-where, thickened into shadow masses in places—always irregular and responsive to the underlying body, varied like the surface they bound, with its range of warm and cool in the same blue. Straightforward and simple as it looks, the paint-ing is deeply contrived, with many unobtrusive repeats—rhymings of colours and shapes: the green of the beard and the table, the reds of the face and the lower left corner of the picture, the small characteristic angularities, the corner of the table, the lapels, the shirt front, the chair seat, etc. And a challenge to the observer who wishes to understand as well as enjoy: the lightest tone of all, the triangle of white beneath the beard—an unmistakably right and indispensable decision.

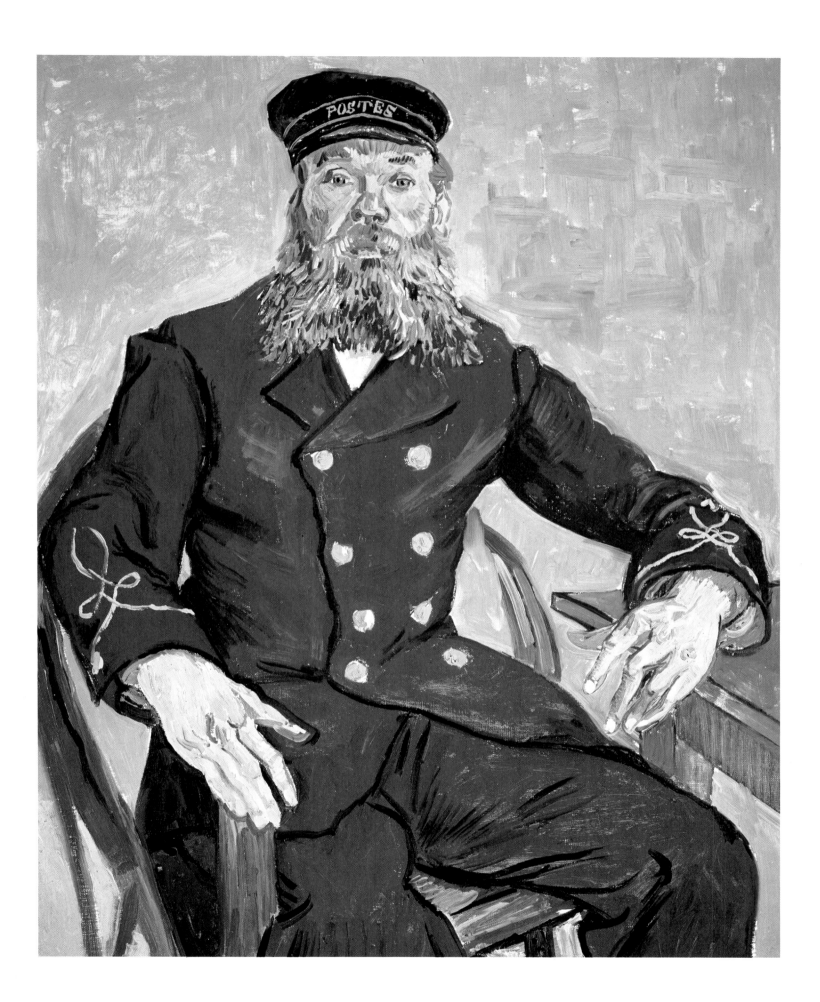

Painted June and August 1888, Arles

THE ZOUAVE

Private Collection, South America

$(31\frac{7}{8}'' \times 25\frac{5}{8}'')$

THE zouave was, like van Gogh, a foreigner, whose occupation made France his country; but he remains an outsider. It is the portrait of a type, very true in rendering the simple watchfulness and confidence of the Arab, the rigidity of the man of the lower classes in sitting for his picture; it has the native character of the Arab in the widely parted legs on the low seat.

In this gay military costume—a means of forgetting death and attracting the eyes of the unenrolled—the colours have also, through the artist's arrangement, that symbolic expressiveness of which van Gogh speaks in his letters. The animality of the dark head, still restrained in the red turban and in the dark blue jacket, bursts out in the fiery flaring trousers. The significant division of the picture is not of left and right, but of upper and lower halves. The upper half is cool and sparse, with the figure contracted, stable, symmetrical, ornamented with perfectly legible detail, and set to one side of its space against a cold plastered wall enclosed by perpendicular bands of green. The lower half is dominated by the shapeless, barbaric, vermilion trousers above a reddish ground, even more unstable through the network of its tiles and joints (a Japanese motif)—diagonal streaks of the same family as the converging highlights and folds that slash the stronger red, and clearly opposed to the curved ornament of the jacket. There is in the immense spread of the trousers a kind of perspective which gives to the contrast of the lower and upper parts the value of a passage from the intensity of the near to the more subdued quality of what is beyond. The feet take part in this perspective of the figure, adding by their divergence to the complexity of the pattern of the floor. Here should be mentioned the adroit recurrence of the white and green of the wall and sash in the tripod formed by the shoes and the leg of the stool, an example of van Gogh's inventiveness in uniting the two sharply opposed halves of the work through common features of colour and line. It is a brilliant, original work both in colour and in the ingenious construction of shifting contrasted symmetries from part to part.

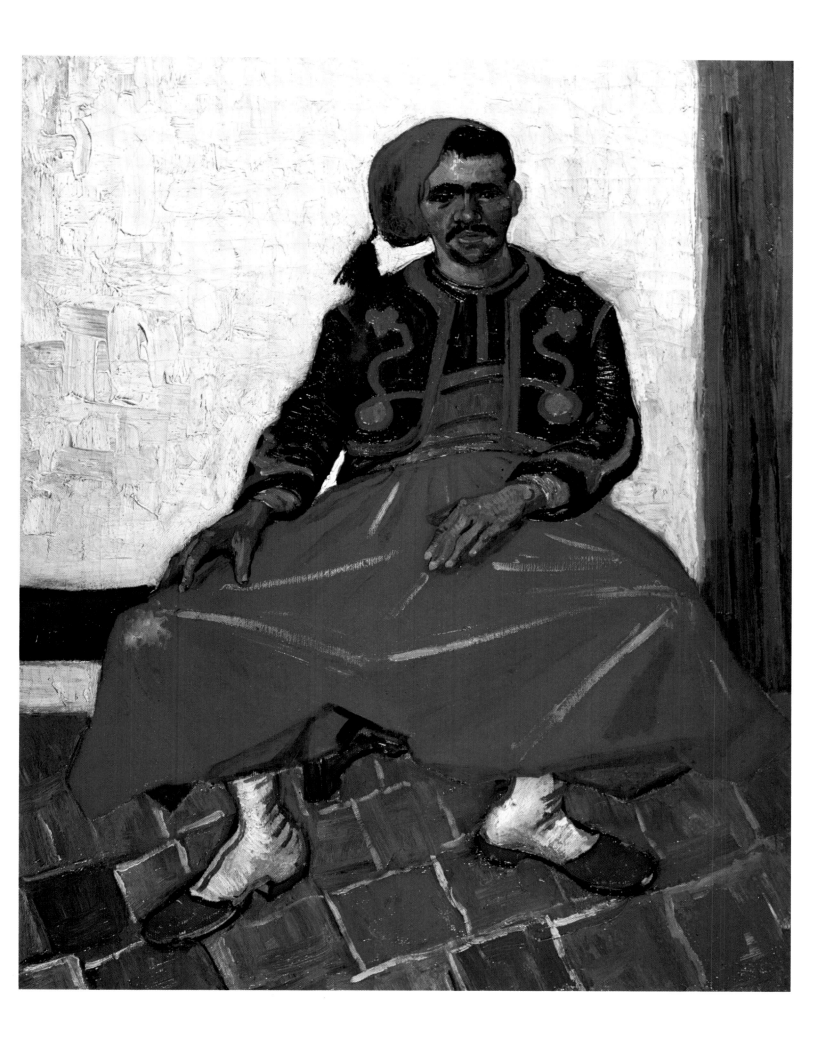

Painted August 1888, Arles

OLD PEASANT (PATIENCE ESCALIER)

Collection Stavros S. Niarchos

$(27\frac{1}{8}'' \times 22\frac{1}{8}'')$

COMING to Provence from Paris, van Gogh rediscovered the peasantry which had been his chief subject during his first years as a painter in Holland. This Mediterranean peasant is formed of the sun as well as the earth; his substance glows, without losing its earthy brownness; his blue cape and the burnt orange background are an inversion of the Provençal sky and earth. Most compelling, however, is the profound image of the man which, speaking to us at first through the eyes and then through the whole face, also conveys his strength through the masterfully drawn hands, and finally through the posture, the costume, the very partitioning of the space which he dominates. Of a rugged force, of a great simplicity and frankness in its large aspect, the portrait is focused upon a face of an unsoundable depth and complication. Every feature is a world with its own shapes, colours, movement, and character, all the features uniting in the gravity of this ancient peasant nature fixed in earnest attention. The sheer power of representation is astounding; the luminosity of the red-fringed eyes, the colourful shagginess of the beard, all infused with the robustness and vitality of the varied brushwork which seems to follow pre-ordained paths and evokes an organic rhythm of the head. Great taste—let us say more rightly great understanding— appears in the gradation and contrast of the parts with respect to fullness of detail; the supreme region of the face, which contains all the colours of the painting like the palette source, under the brown shading brim, uniform in colour; the yellow hat above, simple though more broken; the blue smock, complementary to the background in colour, still more divided, and related in its many folds to the streaking of the beard; the three red spots of the cravat and the sleeves in a strong, concentrated pattern enclosing the hands, and supporting the head. This is perhaps the last realistic portrait of a peasant in the tradition of Western painting. It is perhaps also the only great portrait of a peasant.

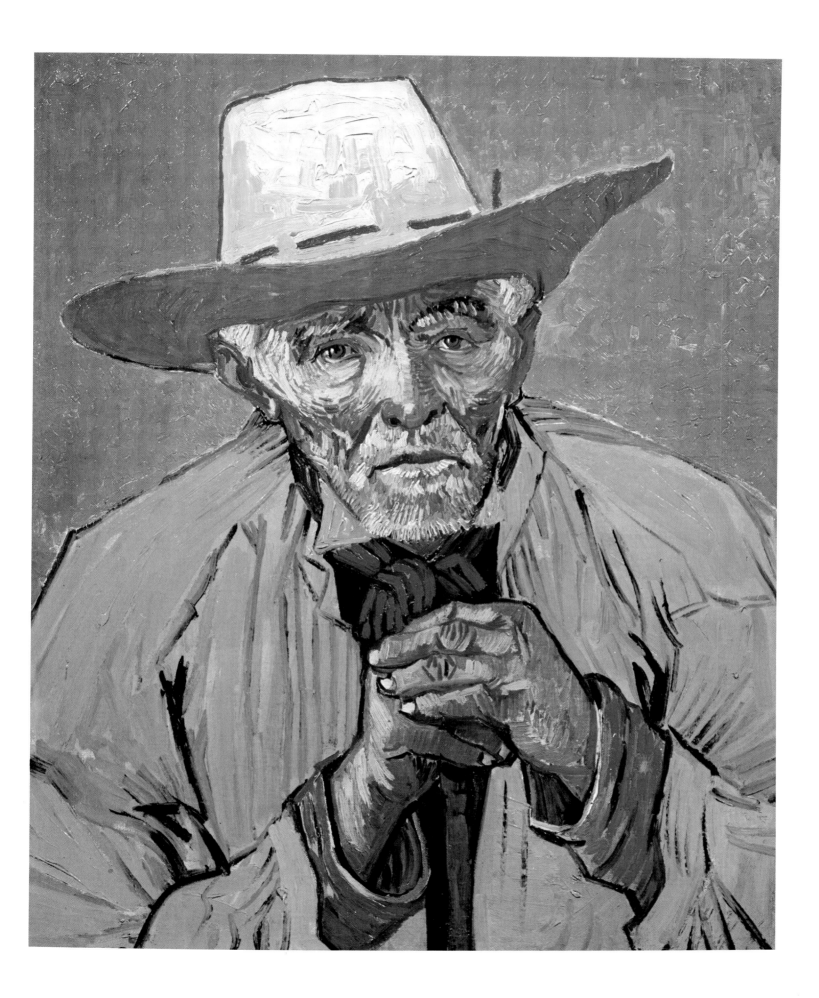

Painted August 1888, Arles

OLEANDERS

The Metropolitan Museum of Art, New York. Gift of Mr. and Mrs. John L. Loeb, 1962

$$(23\tfrac{3}{4}'' \times 29'')$$

IN placing a copy of Emile Zola's *La Joie de Vivre* (*The Joy of Living*) beside the jug of blooming oleanders, van Gogh announces to us the sense of his love of flowers. They rise and spread across the breadth of the picture like the blossoming trees of his spring landscapes. Heavy, profuse, fertile, these fragrant flowers are painted with a virile touch in circling strokes and thick parallel dabs, in sharpest contrast to the spiky, entangled green leaves outlined in black—the carriers of another vitality. Opposing and completing this span of reds and greens are the yellow and violet chords of the books, the table shadow and the jug; between these pairs of complementaries mediates the yellow-green background, a strong note in harmony with both. This is not, however, a system of parcelled decorative colouring: in the rich variation, interweaving and stepping of tones, it retains the vibrancy and freedom of van Gogh's landscapes. Pink tones in the flowers approach the colour of the table, and their whites, the edge of the book. The purple handle makes a triad with the flowers and the lilac shadow. The yellow band at the neck of the jug reappears as wavy stripes in the bouquet. The green of the leaves reappears in a cooler whitened tone at the base of the jug, and in brusque strokes at the right of the table, but also in the ornament of the jug; and this turquoise note returns unexpectedly among the leaves themselves. The strongest accents of red in the flowers are applied again with great daring along the edge of the table—a pure artistic decision, unmotivated by nature. The lilac shadow is another bold choice, justified by its place between the yellow book, the turquoise and blue-violet vase, and the yellow-green of the background. Striking to modern eyes is the drawing of the two books; odd in perspective, they form a succession of oblong and triangular strips, distinct in texture, which we find again in late cubist designs. Magnificent in audacity beside the carefully drawn leaves is the painting of the table, joyous in its abandon and in the variety of colours and brush-strokes. Like most of van Gogh's still lives, this one possesses a high luminosity together with an astonishing firmness and tangibility of the objects.

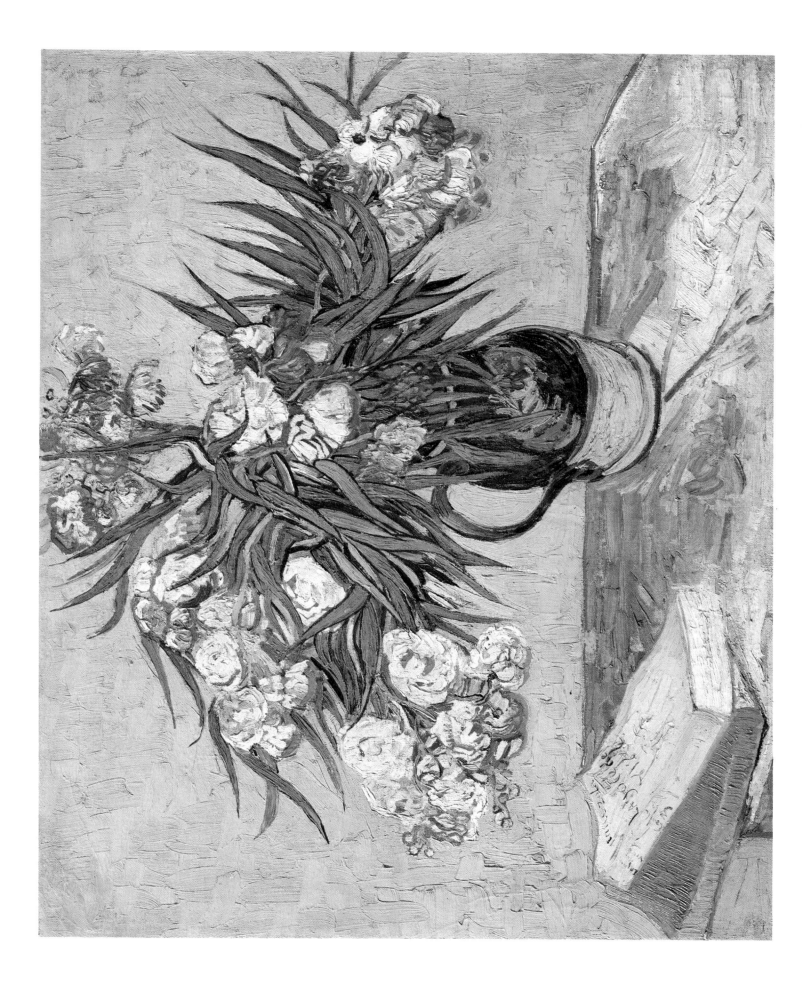

Painted August 1888, Arles

SUNFLOWERS

The National Gallery, London

$$(36\tfrac{1}{2}'' \times 28\tfrac{3}{4}'')$$

F O R the decoration of his room, Vincent conceived a series of panels of sunflowers against backgrounds of yellow and blue. He had already painted these golden flowers in Paris, lying separately on the table. His new conception was more lyrical, an effort to possess the full radiance of these joy-giving flowers. His enthusiasm for them announces the aesthetic of the 1890's, which drew from the advanced biological and moral ideas of the time a kind of aesthetic vitalism, a confidence in nature as a model of health and fulfilment through growth and latent instinctive energies of the individual.

It is therefore not the traditional decorative still life of varied flowers but a piece of the sun, a poem of joy in light and intense growth. Vincent had to rise with the sun and paint these plants rapidly in early morning before they faded. The intoxication of the yellow sunlight colours the entire canvas; it is indeed a composition of yellow. With little formality or searching, van Gogh has found an arrangement which is free, balanced, and generous in substance, exhibiting the whole scale of the qualities of this giant flower. His brush, with its usual directness, seeks out the varied textures and tones of petals, disks, leaves, and stems against the common luminous ground.

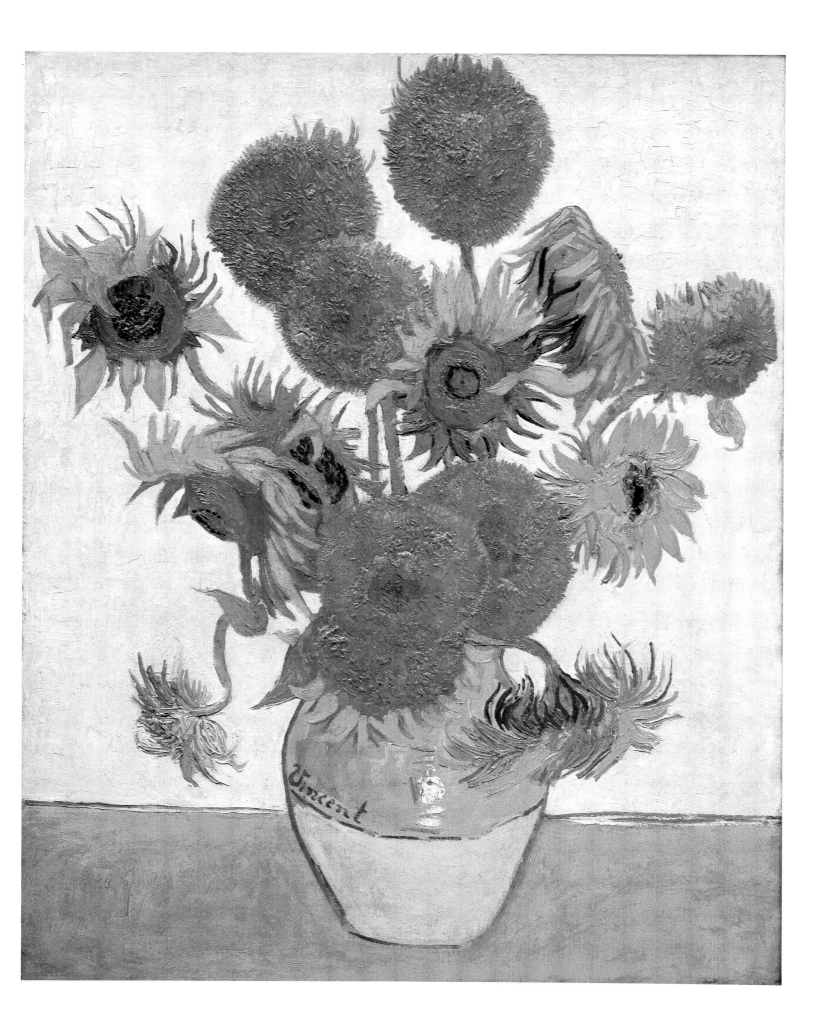

Painted September 1888, Arles

THE NIGHT CAFE

Yale University Art Gallery, New Haven.
Bequest of Stephen Carlton Clark, B.A., 1903

$(27\frac{5}{8}'' \times 35'')$

VAN GOGH judged *The Night Café,* which he painted for his landlord to pay the rent, "one of the ugliest pictures I have done". Yet, it gave him great joy to paint, and there are few works on which he has written with more conviction.

He has gone here beyond the agreeable side of the café world, imaged by the Impressionists, to its darker disquieting moments. The homeliness of the drawing, the interest in objects, the pervading moral concern, remind us of his Holland works. And indeed he spoke of it as "the equivalent though different, of the *Potato-Eaters*", which it recalls by its lamplight; it is a powerful corresponding image of an opposite human condition—of the dissipated and homeless. But let us quote his own strong description.

"I have tried to express the terrible passions of humanity by means of red and green.

"The room is blood red and dark yellow with a green billiard table in the middle; there are four lemon yellow lamps with a glow of orange and green. Everywhere there is a clash and contrast of the most alien reds and greens in the figures of little sleeping hooligans, in the empty dreary room, in violet and blue. The blood red and yellow green of the billiard table contrast with the soft tender Louis XV green of the counter on which there is a nosegay in rose colour. The white coat of the patron, on vigil in a corner of this furnace, turns lemon yellow, or pale luminous green."

Some days later, he wrote: "I have tried to express the idea that the café is a place where one can ruin one's self, run mad or commit a crime. So I have tried to express as it were the powers of darkness in a low drink shop . . . and all this in an atmosphere like a devil's furnace, of pale sulphur, all under an appearance of Japanese gaiety and the good nature of Tartarin."

In his account, van Gogh says nothing of one of the most powerful effects: the absorbing perspective which draws us headlong past empty chairs and tables into hidden depths behind a distant doorway—an opening like the silhouette of the standing figure. To the impulsive rush of these converging lines he opposes the broad horizontal band of red, full of scattered objects: the lights with their great haloes of concentric touches, the green clock at the midnight hour, and the bouquet of flowers, painted with an incredible fury of thick patches against the smooth wall above the crowd of bottles.

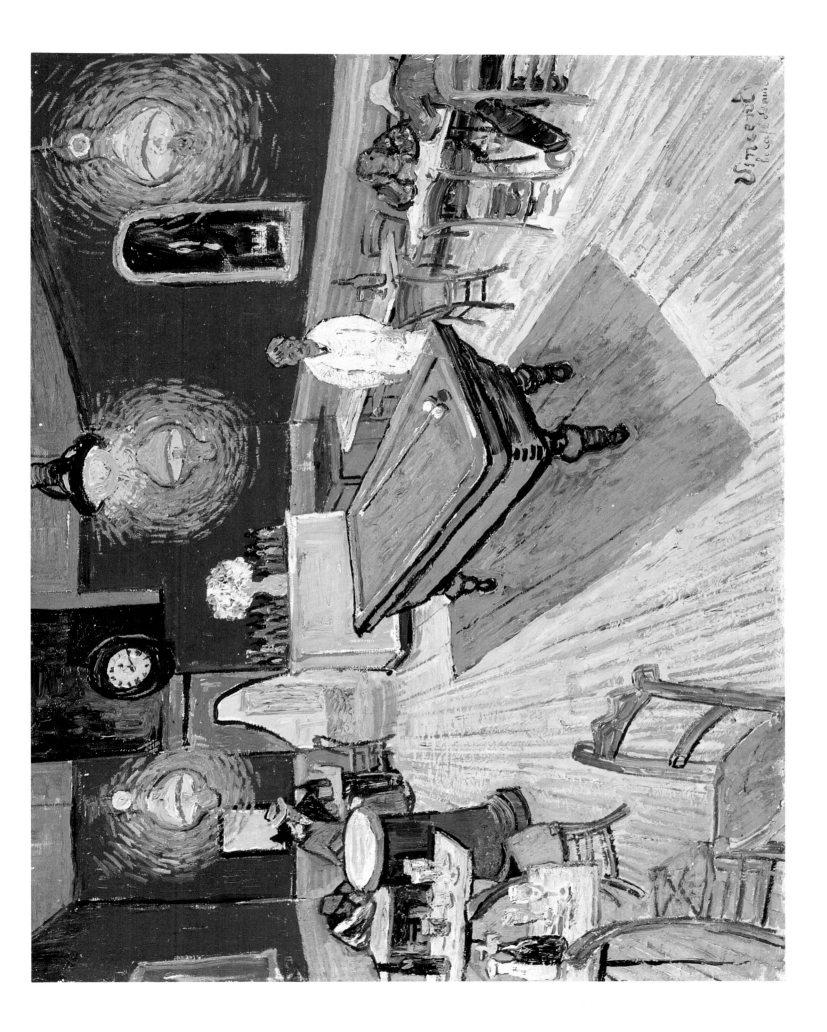

Painted Fall 1888, Arles

PAVEMENT CAFE AT NIGHT

Collection State Museum Kröller-Müller, Otterlo, The Netherlands

$$(31\tfrac{7}{8}'' \times 25\tfrac{3}{4}'')$$

PAINTED at the same time as *The Night Café* (page 71), this colourful outdoor view is a less dramatic, more picturesque work, the vision of a relaxed spectator who enjoys the charm of his surroundings without any moral concern. It recalls van Gogh's mood when he wrote that "the night is more alive and more richly coloured than the day". Where *The Night Café* is compellingly focused, with a rapid, prolonged flight of lines and a dominant contrast of green and red, the outdoor scene is more casually beheld. The colour is more profuse and the eye wanders along the stepped or dovetailed edges of neighbouring areas—irregular shapes fitted to each other like a jigsaw puzzle design. To divide this space for long into large object and background themes is difficult for the eye; the distant and nearer parts are alike distinct. The yellow of the café plays against the blue-black of the remote street and the violet-blue of the foreground door, and, by a paradox of composition which helps to unify the work, at the strongest point of contrast the awning's blunt corner nearest to us touches the remote blue sky. Foreshortened lines which thrust into depth, like the lintel of the door, are strictly parallel (on the picture surface) to lines like the slope of the yellow awning and the roof of the house above which lie in planes perpendicular to the first. For this roving, unengaged vision the upward dimension is no less important and expressive than the depth.

The silhouette of the starry sky is a key to the patterning of the whole; the poetic idea of the work—the double illumination and contrast of the café and the night sky—is developed through this jagged form. In the silhouette of the orange café floor and the adjoining window and doors, we discover the inverted shape of the blue sky; the scattered disks of the stars are matched in the elliptical table-tops below. If the café stands out as the brightest and most complete object in the scene, it is less defined than the starry sky and its colour is the most unstable, passing from yellow to orange and green, and contrasting sharply with almost all the other colours in the circle of cooler and darker tones around it. Because of these relationships, which determine a rich spectacular effect, the painting is less deeply absorbing, less concentrated than the best of van Gogh.

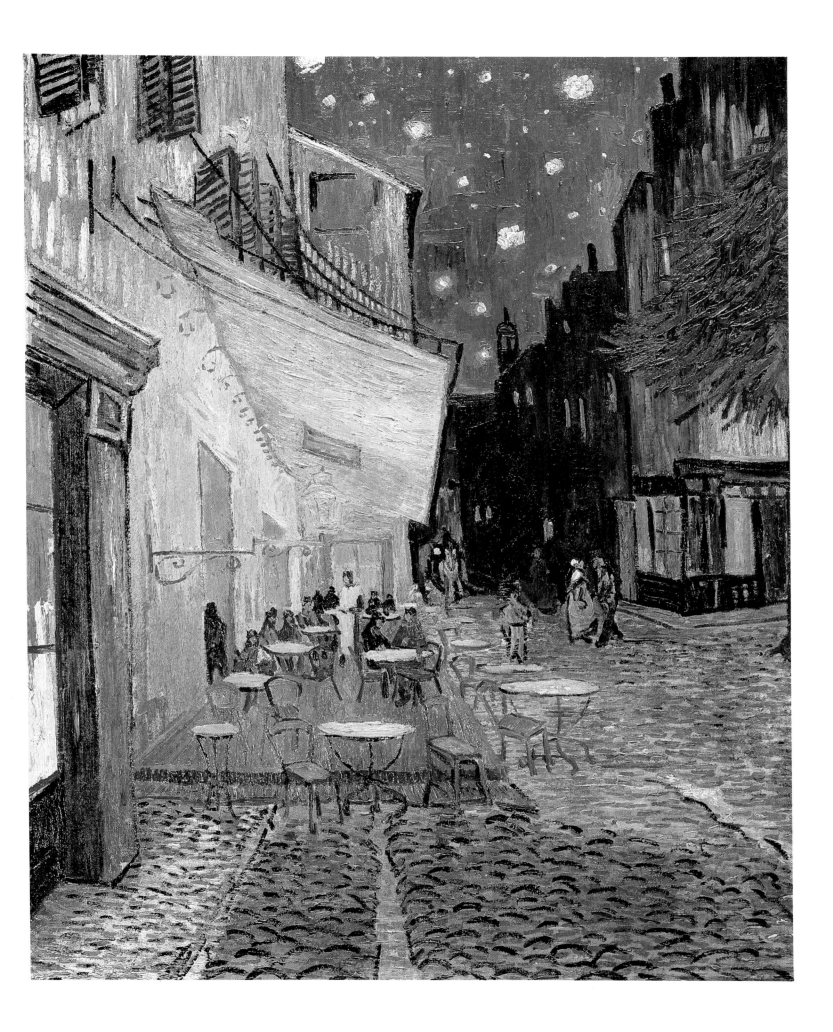

Painted October 1888, Arles

PUBLIC GARDEN AT ARLES

Private Collection

$(28\frac{3}{4}'' \times 36\frac{1}{4}'')$

ONE of several paintings of the public park, a site dear to the holiday mood of the Impressionists. The true theme here is the magnificent blue pine, which van Gogh admired; it becomes idyllic through the two lovers in blue who emerge hand in hand in its shadow; they dwell in the strength of the venerable prolific tree, which shades and protects them.

The image is startling in the diagonal division of the canvas: one half all richly coloured vegetation, the other mainly sandy walk. This bold partitioning, unstable and strange to the eye, but true to van Gogh's love of sharp perspectives —here applied to a narrow, even intimate, space—is stabilized, quietly reconciled with the normal banding of ground and background, by the lights and shadows of the path and by the spread of the gigantic pine across the entire canvas; it is planted on a deep horizontal shadow which continues, in a greyed tone, across the lighter path. The two figures on the shadow, the only verticals in the canvas, help to fix the place of the tree in the middle distance. And yet the tree's outline at the left prolongs the diagonal of the path—a purposive continuity of a line in depth with a line in surface, practised in Renaissance art and renewed in recent painting.

The harmony of tones is especially delightful. Into the ruling bluish tonality van Gogh has worked a richness of greens and blues and their whitened tints, with a few dispersed touches of warm colour as minor contrasting accents. This blue and green world contains within itself a wide range from light to dark, warm to cool, intense to neutral. In the sandy tones of the path is another order of contrasts, from the smoothness of the warmer, distant lighted part to the vehemently brushed shadows of the foreground, related in their greyed hues to the saturated tones of the vegetation. Above all, the picture owes its vitality to the fervour of the brushwork which, in the luxuriant tree, is a marvel of graphic characterization through rapidly drawn coloured lines. In their diagonals and convergences, these pick up the larger diagonals of the work and the thrust of unaccented angular elements in the surroundings—the lights on the path, the angle of its bend, the man's legs.

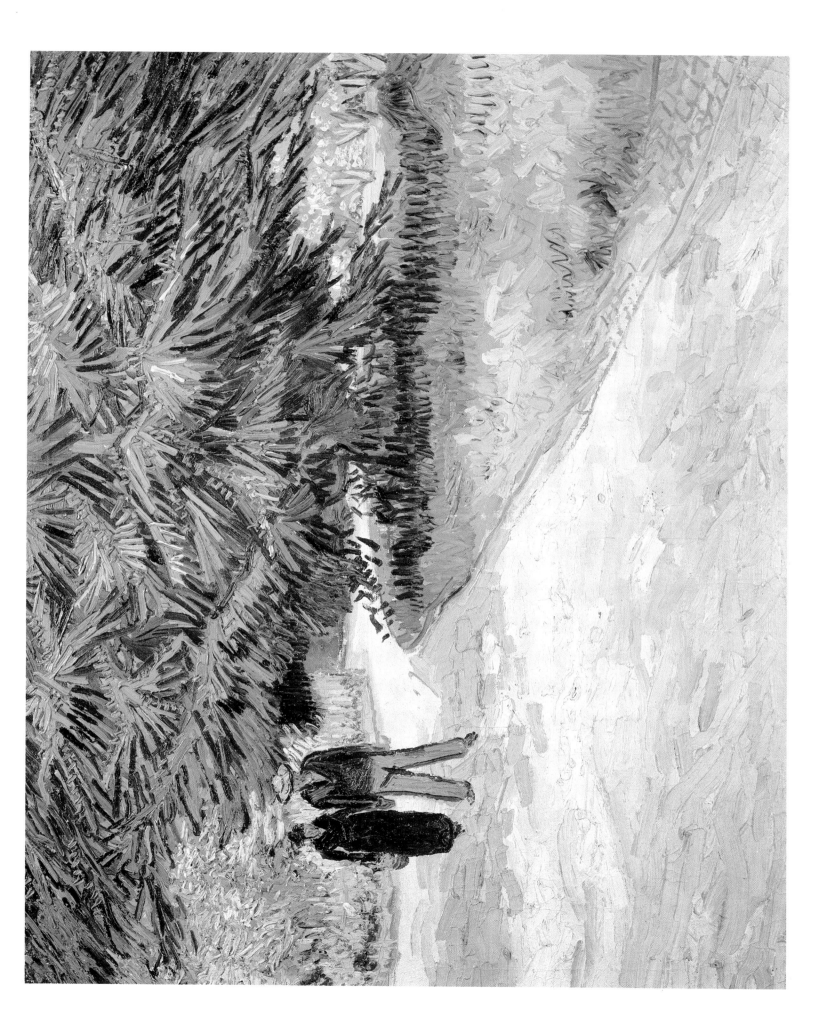

Painted October 1888, Arles

THE IRON BRIDGE AT TRINQUETAILLE

Private Collection, New York

$(29'' \times 36\frac{1}{2}'')$

THIS picture of cold stone, pavement, and iron was painted on a grey morning. The activity of lines—parallel, crisscross and convergent—replaces the variety of colour on which van Gogh usually counts for the life of the painting. The architecture of countless steps and girders offers an exciting, challenging network of lines which he has accepted and tried to render in their framework and skeletal character. To the complication of the rigid asymmetrical architecture he has added the complexity of the perspective which determines the rivalry of the sharp diagonal vista through the arch at the right and the divergent zigzag view of the ascending steps and the bridge, with its dizzying succession of parallel and converging lines, culminating in the crisscross of girders. Very different from his contemporary, Seurat, whom he admired and imitated, van Gogh did not see in the mechanical constructions of his time a beautiful rational form, satisfying to the artist's search for perfect stability and order; but he extracted from them the most intricate and unstable aspect as a balanced maze for the eye. To the definite directions and smoothness of the drawn parts, he opposed the turbulent execution of the thickly patched, pale sky and road. The rigidity of the geometrical is softened by the free-hand drawing and by the scattered touches of humanity and nature. Curious for the eye and a sign of van Gogh's deliberateness as an artist is the drawing of the woman in perfect line with the lamp-post—a device which helps to unite the farther and nearer parts of the space into a cohesive pattern. This long vertical is one of a series of verticals, including the trees, which transform the architecture of the scene into the architecture of the painting.

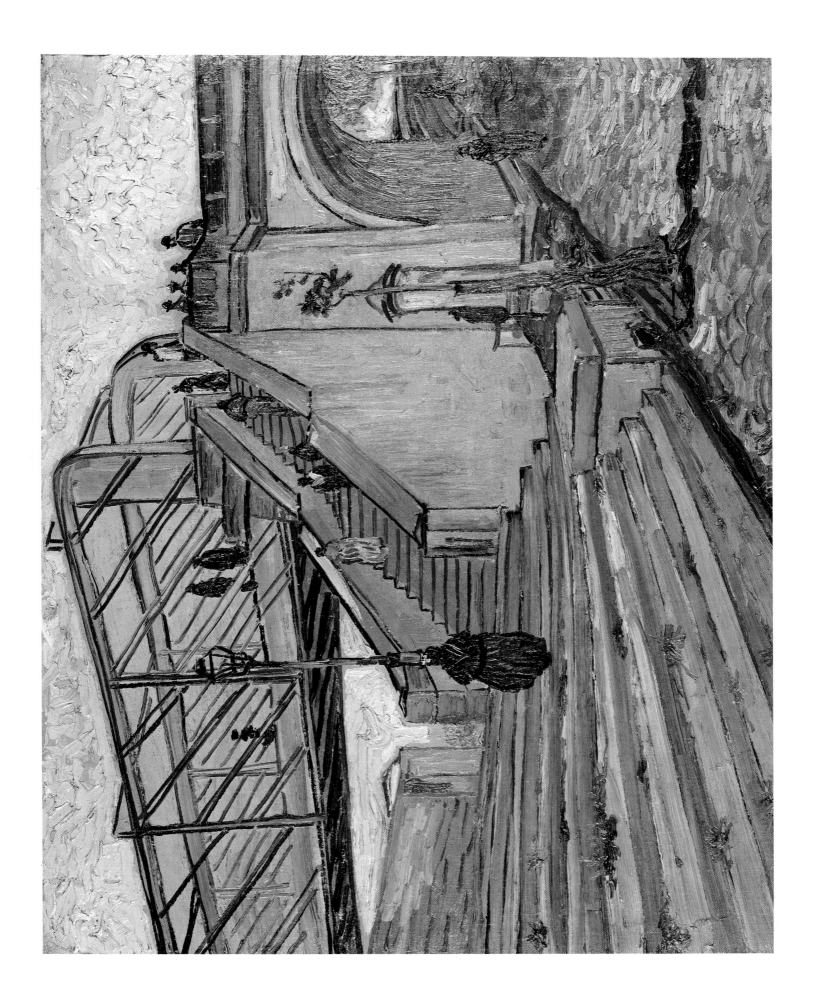

Painted October 1888, Arles

THE BEDROOM AT ARLES

The Art Institute of Chicago. Helen Birch Bartlett Memorial Collection

$(29'' \times 36'')$

To van Gogh this picture was an expression of "perfect rest", or "sleep in general". Painting it, the bright, cheerful little room became a field of rapid convergences, sharp angles, and contrasts of high colour. The perspective vision of the walls and bed is as exciting as one of his deep landscapes, where we are carried headlong to the horizon. But in such a view with "a rushing series of lines, furrows rising high on the canvas", van Gogh found an expression of "calmness, of great peace". These surprising reactions permit us to see the spontaneous intensification of movement in his rendering of things. For his high-strung nature, the most relaxed perceptions were already charged and restless. But his feeling of repose in paintings so full of movement is also the outcome of a kind of cathartic process; by projecting movement into nature, he is relieved of tensions and wins a real peace.

In the *Bedroom* this movement is sustained by a delightful, inventive play of scattered objects. As we follow the converging lines of the floor and bed to an unmarked point, we come to a rival perspective system in the dark lines of the casements, of which the repeated angles occur again in a series of surrounding objects of different colour and complexity: the distant chair and table, the picture wires, the ceiling corner, and the inclined pictures at the right. Together they form a free pattern of zigzags across the space, flattened and softened in the wavy lines of the bedboards.

In the colour van Gogh has played with still other competing centres of sharp contrast; the pairing of light yellow with stark vermilion, the strongest note of colour in the picture; diagonally opposite, the black-framed mirror with its intense light, the brightest tone in the entire work. These colours, unexpected, isolated notes, lie outside the prevailing luminous scheme of yellow, orange, and blue. Within that system are interesting alternations of tones—the yellow and orange of the furniture, the green and yellow of the window; these remind us of primitive patternings of colour.

We must observe finally the striking naïve realism in the objects, with their clear shadowless forms. We sense the coarse wood grain of the bed and we handle the frankly rendered still life on the table. Their simplicity is part of a powerful mood of the artist who lives there and imposes on this intimate world his own intensity of feeling.

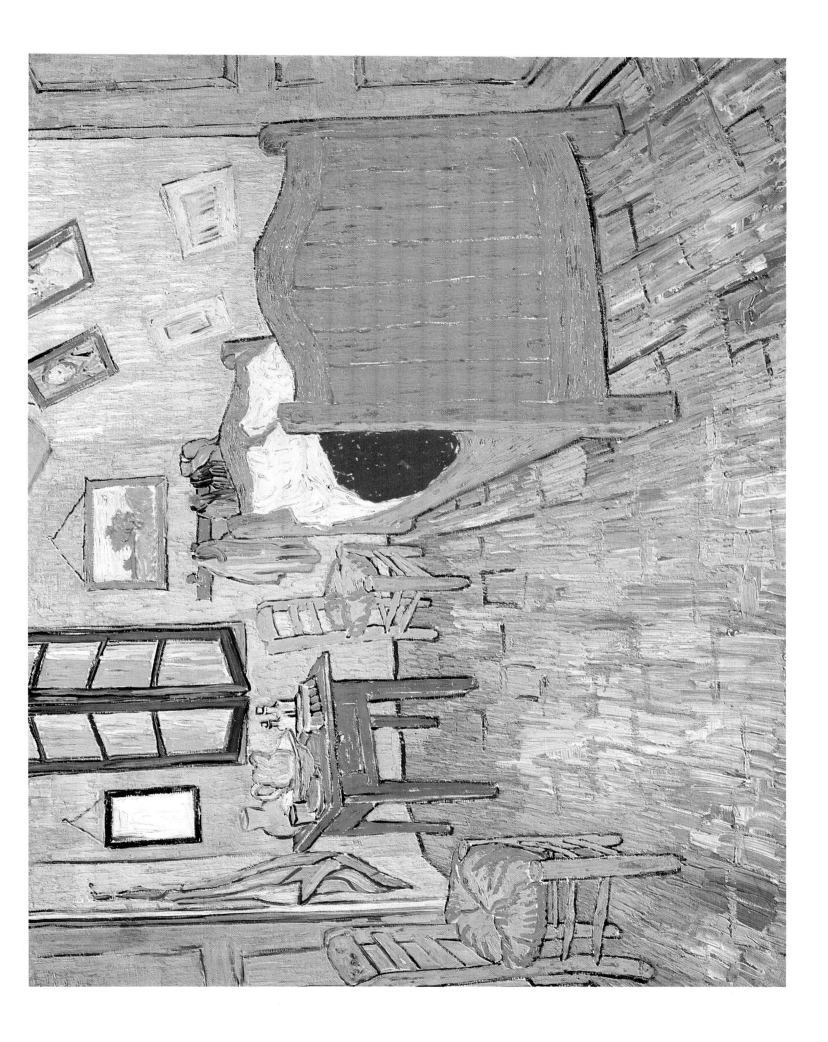

Painted Fall 1888, Arles

THE SOWER

National Museum Vincent van Gogh, Amsterdam

$$(12\tfrac{5}{8}'' \times 15\tfrac{3}{4}'')$$

IN this tiny canvas, van Gogh wished to apply the lessons he had learned from Japanese art: composition of strong diagonals, objects cut by the frame, flat areas of pure colour, whimsical shapes determined by the irregularities of nature. He retains, however, the full evidence of the brush and the impetus of the hand, which is foreign to the Japanese prints he loved; and a nuancing of atmospheric colours in light and shadow that is strictly Western. Not pure intense colours, but rare tones like the apple green sky which take the observer out of the familiar world and awaken him to astonishment and reverie and submerged currents of feeling. In van Gogh's conception of the figure and the tree, there is a mysterious affinity in colour, silhouette and direction, like an unexpected rhyme which unites otherwise unconnected words and gives a greater resonance to both.

Decisive for the mood of the work is the vision of the distant colourful world through the dark neutralized tones of the foreground objects, and the position of the gigantic sun between them.

In the network of lines, we may observe van Gogh's great intuitive command of the harmony of directions and his freedom in deploying the elements given by nature.

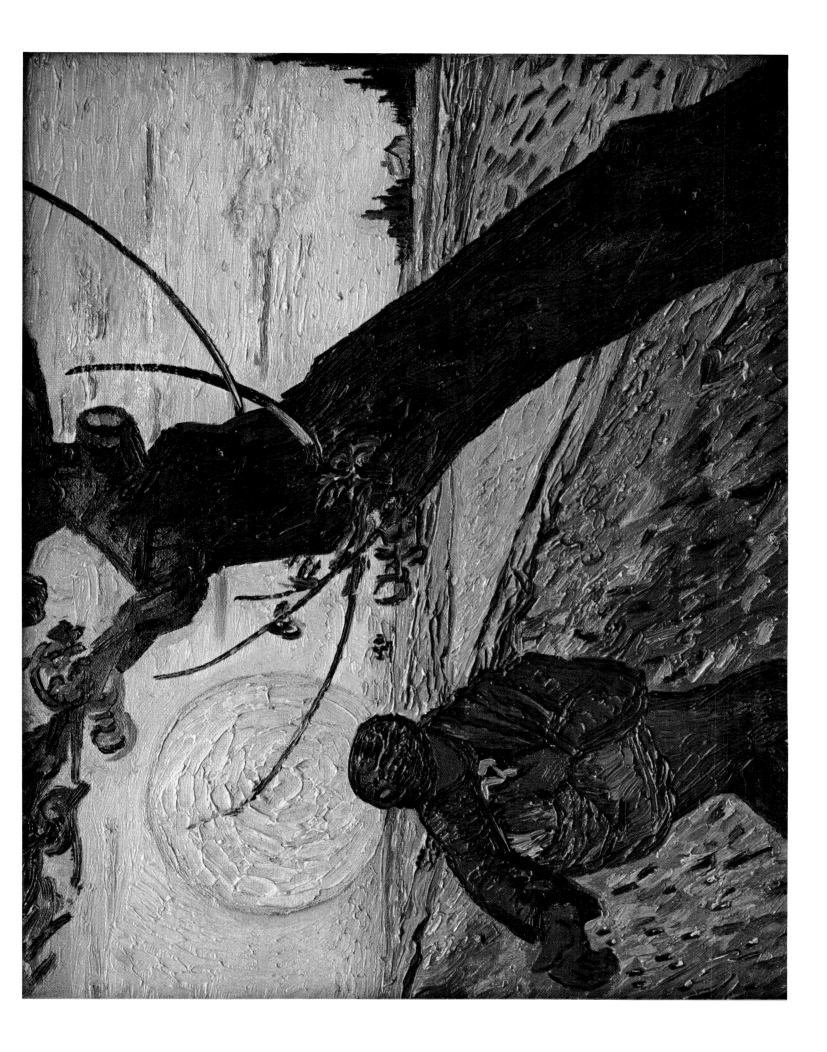

Painted November 1888, Arles

PORTRAIT OF ARMAND ROULIN

Museum Boymans-van Beuningen, Rotterdam

$(25\frac{5}{8}'' \times 21\frac{1}{4}'')$

TURNING to the postman's son, a boy of seventeen, van Gogh changes the terms of his painting. For the adolescent—shy, self-absorbed, with averted glance, and sloping shoulders, not yet fully at home in his clothes—van Gogh selects a scale of darker, more moody tones. Here the contrast of the figure with his surroundings: dark violet-blue almost black against the subdued green, and a face of reverie rather than strength—an age which does not yet know its own mind; in the portrait of the father, a powerful emergence of a strong blue from a lighter blue and the assertion against this blue of his own dominating nature in the brilliant warmth of the features. In this direct informal portrait which looks so unarranged— as if the artist desired only an adequate image—we find also an imagination at work in the strong characterful drawing of the broken silhouette, in the bold simplicity which in assimilating the colour of the hat to the jacket, including even the hair in the common dark boundary, constructs a casual, hidden symmetry, full of unexpected complication and beautiful chords through the pairing of head and cravat, between the two dark masses. The unexpected warm highlights of the tie light up this beautifully patterned region; the long pointed form, very dear to van Gogh, recurs in the neck and the bit of hair on the forehead. Very fine is the drawing of the outline of the face, broken by some features and enclosing others. A work of great simplicity, subtlety and truth.

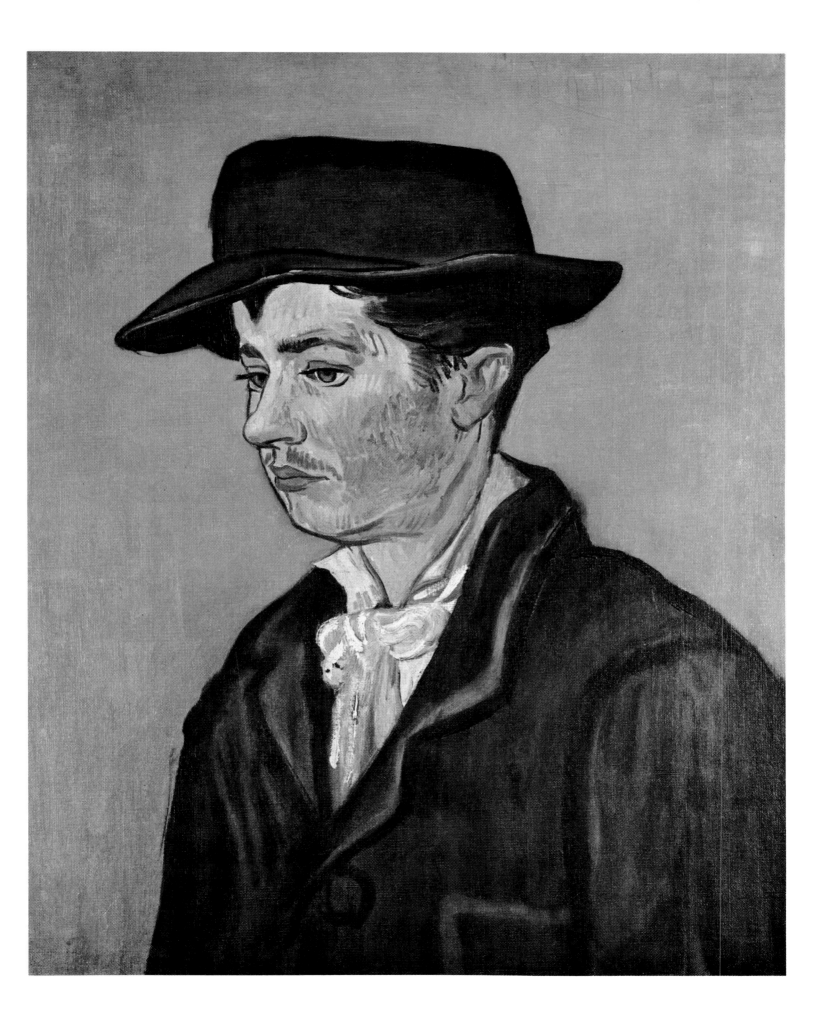

Painted November 1888, Arles

PORTRAIT OF ARMAND ROULIN

Museum Folkwang, Essen

$(25\frac{1}{2}'' \times 21\frac{1}{4}'')$

THE second portrait of Armand Roulin is more beautifully drawn, with soft, fluid lines, in harmony with the lighter tones and the more open mood of the subject. The drawing is perfectly precise, but relaxed and without accents. The lines of the yellow jacket rise in varied patterns—simple, mounting, blue lines on the arms and shoulders, more playful, wavy and zigzag lines within— converging upon the finely drawn head, with its multitude of shadowless, nuanced tones in a narrow range of light and dark. The hat—of a subtle blue used also in the drawing of the outlines, in the hair and eyebrows, in the vest and button— is a fascinating shape, symmetrical as a whole, irregular and free in detail, like the conception of the entire work. The linking of the face to the soft light-green background is of a masterly refinement; this pale, indescribable flesh colour contains delicate pinks, complementary to the background, and a range of cool and light greens that belong with the background colour. Tiny yellow highlights of the eyes and a dash of yellow on the chin refer to the yellow jacket. The execu- tion is soft and tender, with little pressure, and of an unusual thinness of the pigment, in places like a water colour. It is in spirit an outdoor summer portrait in which van Gogh's frank, loving vision, his delight in the presence of a young individual, determine an indwelling luminosity more human and revealing than the poetic sunniness of Impressionist painting.

84

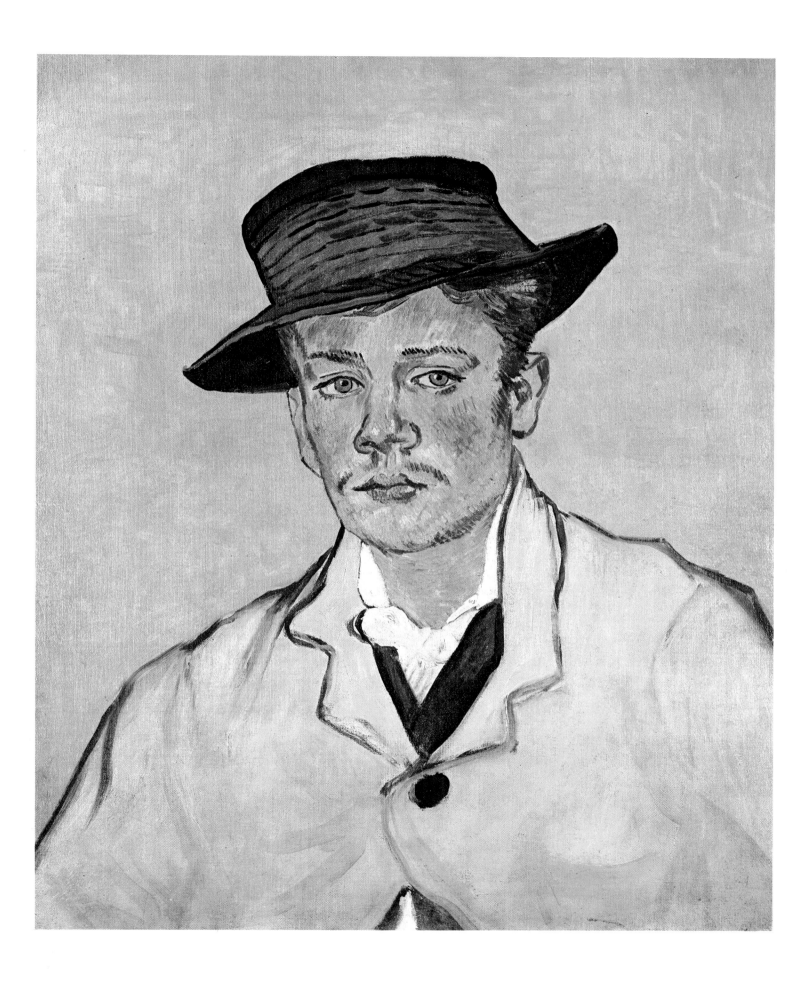

Painted November-December 1888, Arles

MADAME ROULIN AND HER BABY

The Metropolitan Museum of Art, New York. Robert Lehman Collection, 1975

(25″ × 20″)

IN its simplicity and power of elementary contrasts, in its inspired freedom of drawing, this painting could be of the twentieth century. As we follow the broken, intensely mobile silhouette of mother and child we discover a basic realism, a direct, probing vision of live individuals, which is central in van Gogh even when he appears most abstract. Glorified by the yellow ground, this baby—hardly the sweet rococo doll of French pictures of the infant—has already in its ungainly, helpless form the aspect of van Gogh's mature figures who are roughly marked by life. If the staring infant has not yet a spiritual individuality, it possesses the physical individuality of its age with a vividness unique in painting, and which is strengthened for our vision by the shadowy subordinate place of the mother. The drawing, rapid, impulsive, piecemeal, always searching and fresh, circum-scribes the child with an amazing veracity. The asymmetrical outline of the face, scored in black, is penetratingly accurate and of a subtle rhythm. The little arms and hands are perfect and deliciously painted. Deeply expressive is the parallelism of the mother's green profile and the adjoining wavy outline of the child (it belongs also to the background), into which her profile could fit—a characteristic coinci-dence of a harmony of drawing and a harmony of feeling. Equally striking, if not more striking than the powerful drawing (which triumphs over the hasty, unsure rendering of the mother's prominent hands), is the highly original colour, with contrasting luminosities of yellow and tinted white. The yellows comprise a range with close intervals, from the glowing background, through certain flesh tones of the child, to the mother's face, hands and hair. The greens are a broader span of values, from the shading of the baby's clothes to the mother's dress and profile. Finely placed touches of purplish red and black produce minor contrasts, exchanges, echoes, accents, and continuities (like the arbitrary line joining the mother's left sleeve and the baby's dress). The application of the paint, always robust and varied, is another source of intensity. Behind the directness of this portrait of a baby, which could hardly have posed for long, is a finely controlled design; we see it in the brilliant play of analogous silhouettes, including the well-mapped area of the background, and also in the contrasted symmetries of the two pairs of diagonal hands.

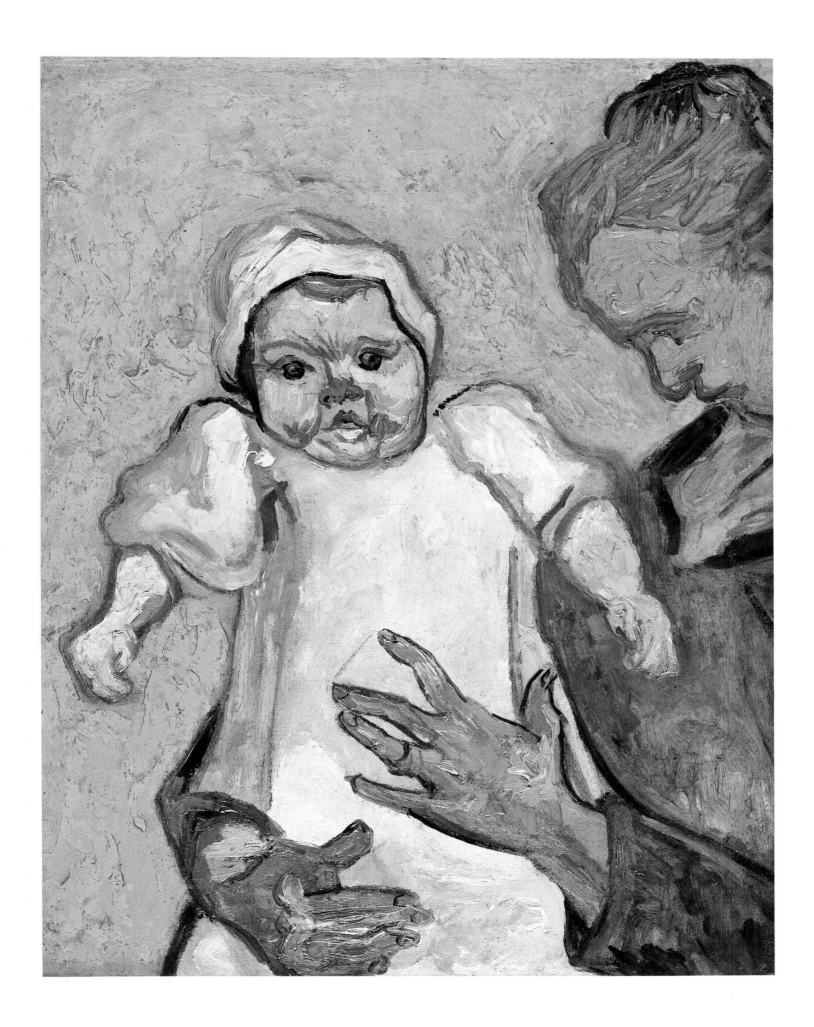

Painted November 1888, Arles

L'ARLESIENNE (MADAME GINOUX)

The Metropolitan Museum of Art, New York. Bequest of Samuel A. Lewisohn, 1951

$(36'' \times 29'')$

IT is Japanese in the flatness and piquant silhouetting on the light ground, but recalls, too, the primitives of Western portraiture—figures turned from the observer, concentrated within themselves, bounded by lines of the utmost precision and set against a perfectly uniform ground. But let us observe also—what is more important—that the painting is unmistakably modern in the deliberateness of the intensity, in the forcing of the medium, and the many traces of spontaneous impulse and fancy in the free execution.

Astonishing and risky is the idea of bringing within one frame the portrait of an individual in reverie and the powerful pattern of extreme contrasts of hues, lights and darks, and intensities. As we fix upon it, the yellowish background, of which the face is a pallid reduction in colour, begins to swallow up the portrait. (This ecstatic yellow which darkens the image of the woman perhaps sublimates a hidden eroticism.) But in the opposed dark blue of the costume and hair—a daring identity—are contained the strongest and most refined forces of characteriza-tion: the irregular silhouette with thorny points, unexpected little projections which belong with the fine breaks produced in the outline of the face by the eyelash and the nose. This dark blue mass is contrasted with the glowing yellow around it and the subdued, bleached, green-whiteness that it encloses. The dark green table supporting the figure in turn encloses that light greenness in the pages of the open book, a yellow like the background, and an intense vermilion which refers us to the chair and the little touches of red on the face and the fichu. This fresh, un-Japanese still life of the books is of a particular beauty and originality, very refined in the treatment of edges, corners, and directions; its angularities, its colouring, are perfectly integrated with the larger masses above. After the first shock of intense heat and stark contrasts, we perceive subtle relationships, a most interest-ingly broken, whimsical, changing silhouette, and inspired juxtapositions of object forms and reserved ground forms. A little detail which reveals van Gogh's artistic tendency: the resemblance of the inclined dark yellow arm of the chair to the slanting spot of yellow in the background under the sitter's right arm. Because of too rapid painting—the picture was "slashed on in an hour", according to van Gogh—the work has suffered; the surface is deformed by numerous cracks and scaling.

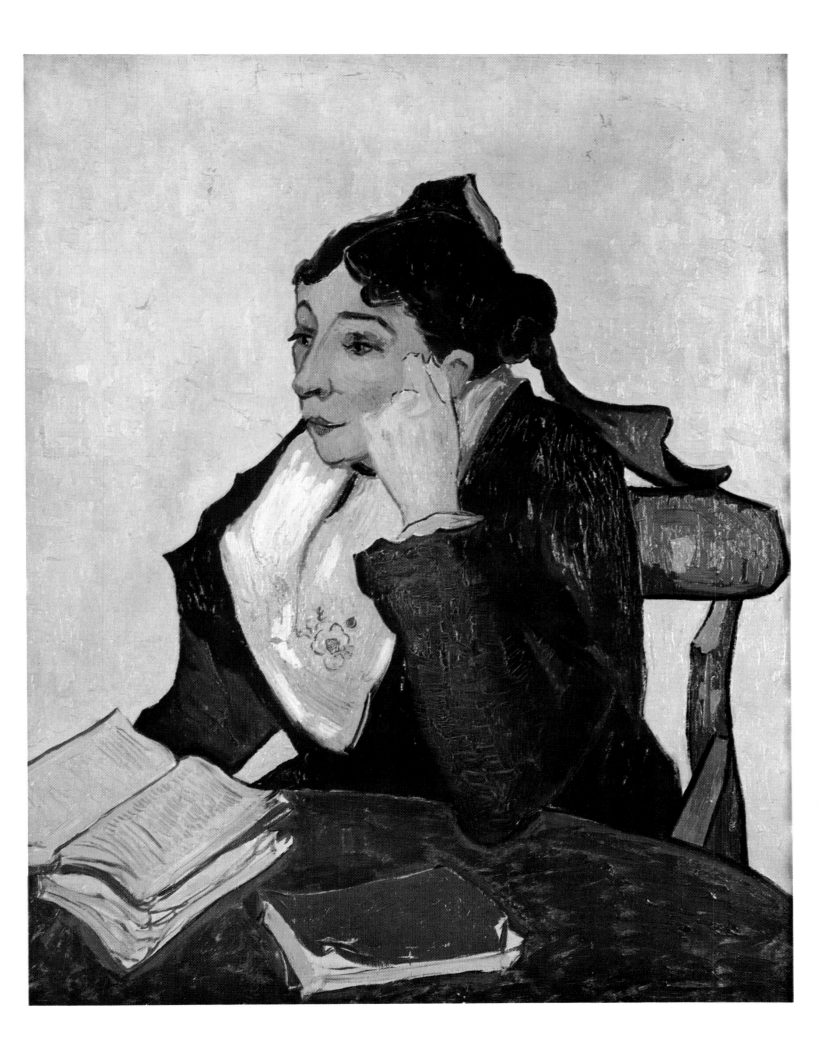

Painted December 1888-January 1889, Arles

THE CHAIR AND PIPE

The Tate Gallery, London. Presented by the Courtauld Fund Trustees, 1924

$(36\tfrac{1}{8}'' \times 28\tfrac{3}{4}'')$

THIS surprising theme is one of a pair. Together with it, van Gogh painted Gauguin's chair on which he set a lighted candle and two books. A fascinating diptych that is more than a still life, for it evokes and symbolizes the human beings to whom these objects belonged, like the attributes of saints in old pictures. When his father died, van Gogh had painted a still life with the old man's pipe and pouch.

The chair, a familiar object which we scarcely know after years of use, has been transposed to the canvas with great fervour; its form and weight and rigidity and texture have been realized in a most complete manner. Van Gogh's conviction about the importance of this chair penetrates us and holds us, until we feel a mystery in its presence. This mystery grows when we see the chair in its surroundings which are also tangible objects, but incomplete; none is an object-for-a-spectator, none has been singled out for a privileged presentation. Underneath the simplicity of the objects, we encounter the difficult involvements of co-existence in the unsteady, bewildering crisscross of the chair-legs and rungs with the joints of the tiles—an involvement that is mostly an affair of chance juxtaposition and perspective, the observer's odd way of looking, which determines an intricacy useless for our knowledge of the chair and ordinarily unnoticed. But not altogether so, for the oblique position of the chair frees it from the surroundings and suggests the freedom of the human being in this rigid geometrical world.

Within the conflicting, intersecting systems of the lines, van Gogh has introduced connecting parallels and continuities. Clearest is the yellowish right angle traced on the door and fitted precisely to the leg of the chair. At the foremost lower rung a zigzag line of the floor reaches from leg to leg. The crossing lines of the rush seat belong as much to the network of the floor as of the chair.

The colour too has an aspect of intricacy in the scale and contact of tones. In the high-keyed scheme, the richly varied yellow, strengthened by the white wall, lies between the orange-red tiles and the cool green door, and is recalled in both through yellowish lines which repeat the directions of the chair. Correspondingly, the blue-green of the door reappears in blue outlines of the yellow rungs and legs, and the darkest brown tones of the tiles in other contours of the chair.

90

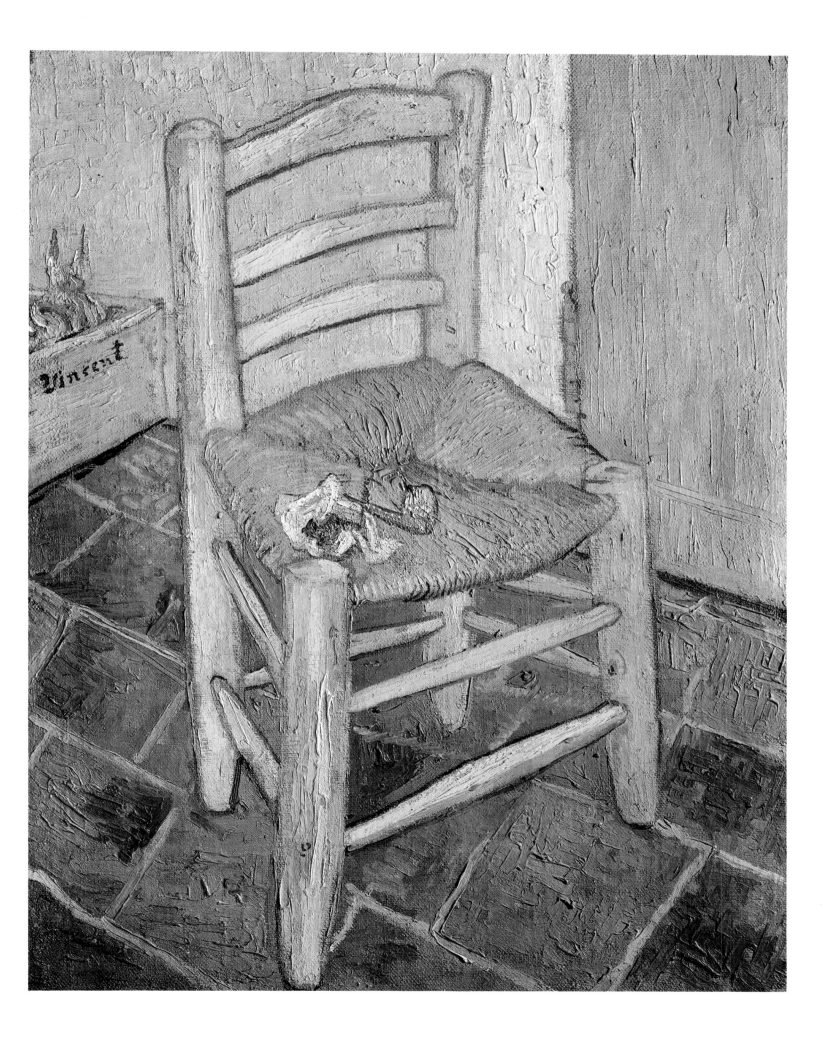

Painted January 1889, Arles

STILL LIFE OF ORANGES AND LEMONS
WITH BLUE GLOVES

Collection Mr. and Mrs. Paul Mellon

$(18\tfrac{7}{8}'' \times 24\tfrac{3}{8}'')$

THE choice of objects is odd, but we recognize in it van Gogh's spirit. In other still lives he has introduced objects that belong to him in an intimate way—his hat and pipe and tobacco pouch, his favourite reading, and in one picture a popular medical book for self-treatment of his insomnia. His still lives are often personal subjects, little outer pieces of the self exposed with less personal but always significant things.

Here the blue gloves, joined like two hands in a waiting passive mood, are paired in diagonal symmetry with a branch of cypress, a gesticulating tree that was deeply poetic to van Gogh. Different as they are in colour and texture, the gloves and the branch belong together; the branching fingers of the gloves are plant-like; and the touches of red on the branch unite still closer these dark blue and blue-green objects. The basket of fruit, in a subtle way, through analogy and contrast, is a bridge between the things it separates: as form, through the intertwining wicker withes, similar to both the cypress and the overlapping and emerging lines of the gloves; and as object, through the passage from nature to artifice and man; for the wicker basket is both plant and vessel, a work of the hand, and the fruit plucked and enclosed for man are nine in number, like the visible fingers of the gloves.

The casual joining of nature and artifact in the still life reappears in the setting of the whole. Where is it? What is this ground, or background? Difficult to say. The light blue-green is a fine sky colour, which we see often in van Gogh's landscapes of Arles, and the greyed yellow belongs to his outdoor ground—an ambiguity that compels us to shift our viewpoint and contributes to an atmosphere in which the natural and the human, the distant and the intimate, merge.

The whole is thinly painted in a rapid, easy, unstressed execution, with a special richness of strokes in the cypress branch.

The colour has great charm, discretion and simplicity. The hues are of less than maximum depth: the orange and yellow fruit slightly subdued; the blues and greens either greyed, darkened, or whitened; the ground and the wicker in neutralized, broken tones of the yellow and orange of the fruit. It is a harmony of different intensities of the same colour and of different colours of the same intensity.

92

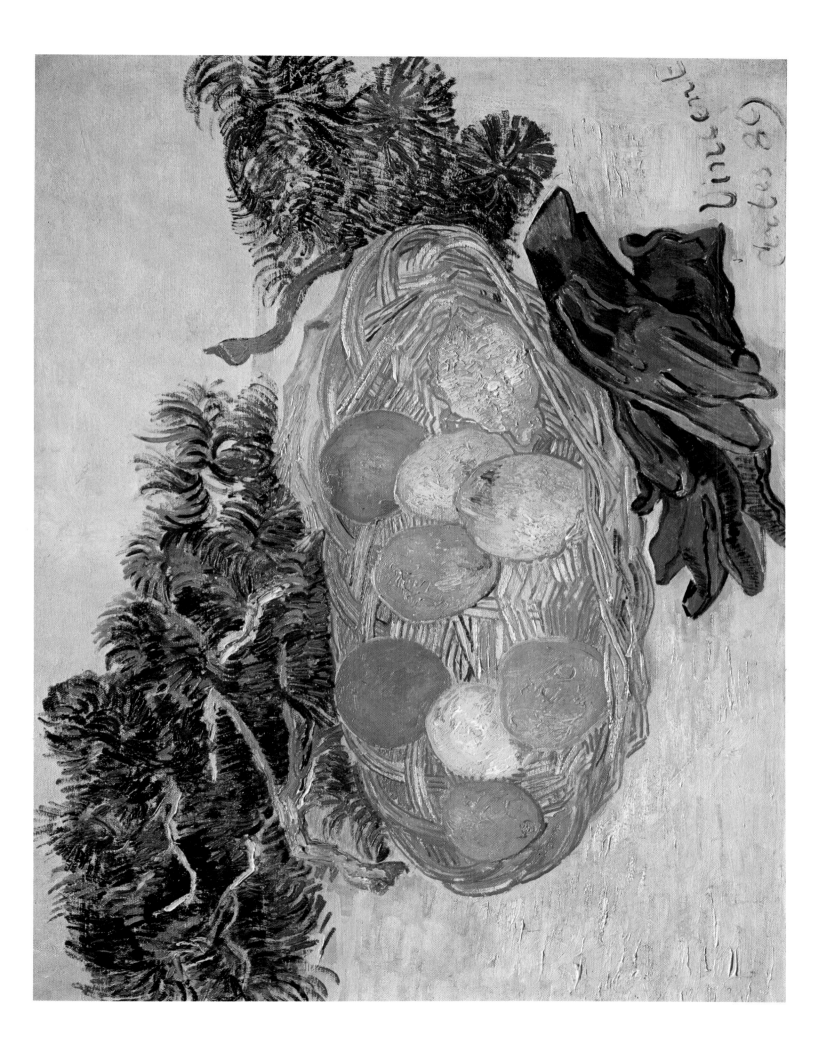

Painted January 1889, Arles

LA BERCEUSE

Museum of Fine Arts, Boston. Bequest of John T. Spaulding

$(36\frac{1}{4}'' \times 28\frac{3}{8}'')$

THE maternal Madame Roulin inspired in van Gogh the desire to repeat her portrait a number of times. He thought this image of a mother beside her infant's cradle could serve as a consolation to the lonely, a reminder of happier days. Hearing from Gauguin about "the Icelandic fishermen, exposed to all dangers, alone on the sad sea", the idea came to him "to paint such a picture, that sailors, who are at once children and martyrs, seeing it in the cabin of their boat should feel the old sense of cradling come over them and remember their own lullabies". His need for solace after the first attack was no doubt behind this conception. We have from his hand five versions; they differ mainly in details of the ornament and in minute aspects of drawing.

It is because of the sentimental idea, addressed to common folk, that he painted the picture in a more legible primitive style, like a chromo—to use his own words —with simple, compact shapes outlined in black, flat pieces of colour cut out and fitted together almost in one plane. He wished also, perhaps, to please his friends Gauguin and Bernard to whom he offered copies of the work; they had talked much of popular and primitive art as models for a new style. If this primitivizing form is latent in van Gogh's previous work, the *Berceuse* is unique among his paintings in the degree of simplification, and remains an exceptional incident in his art. It is no naïve work, however; van Gogh has noted in a letter the counterpoint of varying reds and greens: "A woman in green with orange hair stands out against a background of green with pink flowers. Now these discordant sharps of crude pink, crude orange, and crude green are softened by flats of red and green." The colour is, in fact, more intricately composed, and has a different aspect according to whether we read it in horizontal bands or as figure against background. Van Gogh plays knowingly with the sharply cut-out areas, observing their effects upon one another. To this study we owe the strong construction of the lower half, so rich in angles and so different in mood from the more poetic, fanciful upper half, with its many rounded forms and little parts.

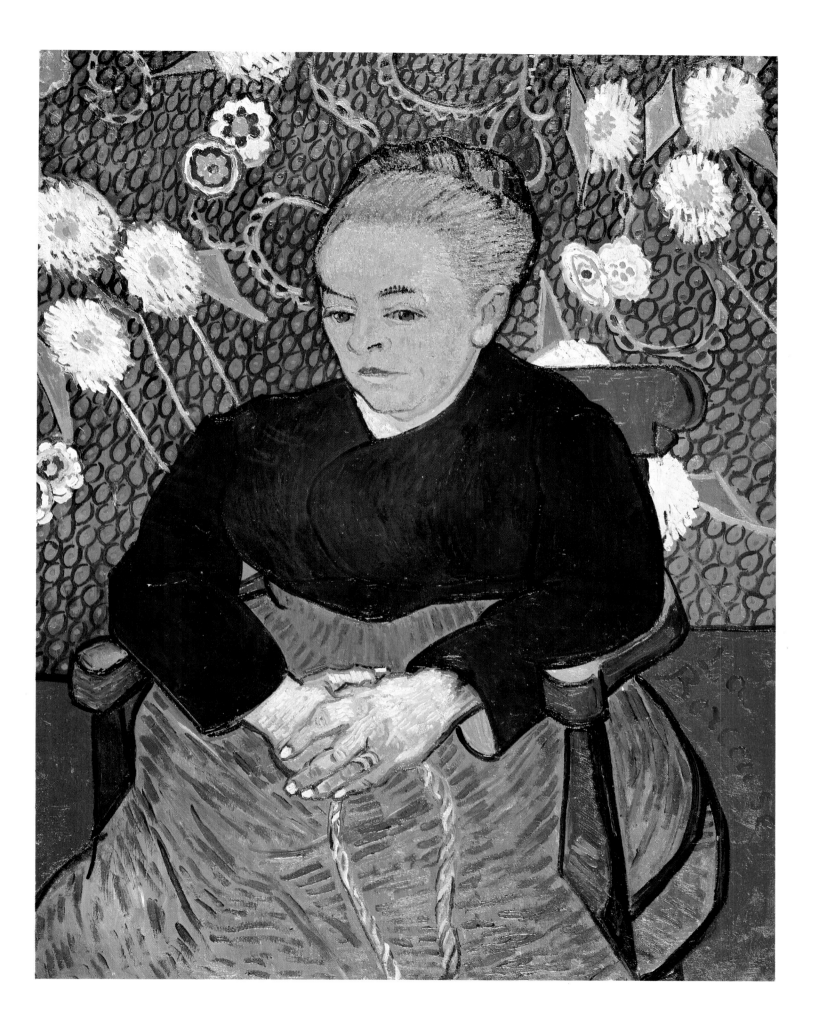

Painted May 1889, Saint-Rémy

IRISES

Joan Whitney Payson Gallery of Art, Westbrook College

$(28'' \times 36\frac{5}{8}'')$

In the asylum at Saint-Rémy, between attacks, van Gogh devoted himself to his art with a desperate determination, knowing that this alone might save him. He called painting "the lightning conductor for my illness". And observing his continued ability to paint, he felt sure that he was not really a madman.

The irises are perhaps the first subject he did in the asylum. It preceded his first attack there and at first glance shows no evident trace of that moodiness and high tension which appear in many of the later works. He paints the flowers with admiration and joy.

The profusion of elements in this close-packed picture is tamed and ordered for the eye without loss of freedom by the division of the canvas into fairly distinct, large regions of colour approaching symmetry: the cold leaf-green in the middle, the iris-blue above and beneath, and in two corners the red ground and the distant warm green, touched with yellow, orange, and white. Each region has its own characteristic shapes and spotting, and all are luminous.

Interesting in the high-keyed colour is that the strongest note, the iris-blue, is the darkest and has also the greatest range from light to dark. In mass of colour, the chief contrast is of this blue with the mild, dilute blue-green of the leaves; their complementary contrasts with red and yellow are secondary and reserved for the margins of the picture. All this helps to temper the luxuriant natural bouquet and to produce a closer, muted harmony, while preserving a gay colourfulness and richness.

Most original is the drawing of the irises. Unlike the Impressionist flower pieces in which the plants are formless spots of colour, these are carefully studied for their shapes and individualized, with the same sincerity and precision as van Gogh's portraits; he discovers an endless variety of curved silhouettes, a new source of movement, in what might easily have become a static ornamental repetition of the same motif. These wavy, flaming, twisted, and curling lines, broken and pointed, anticipate the later works done at Saint-Rémy.

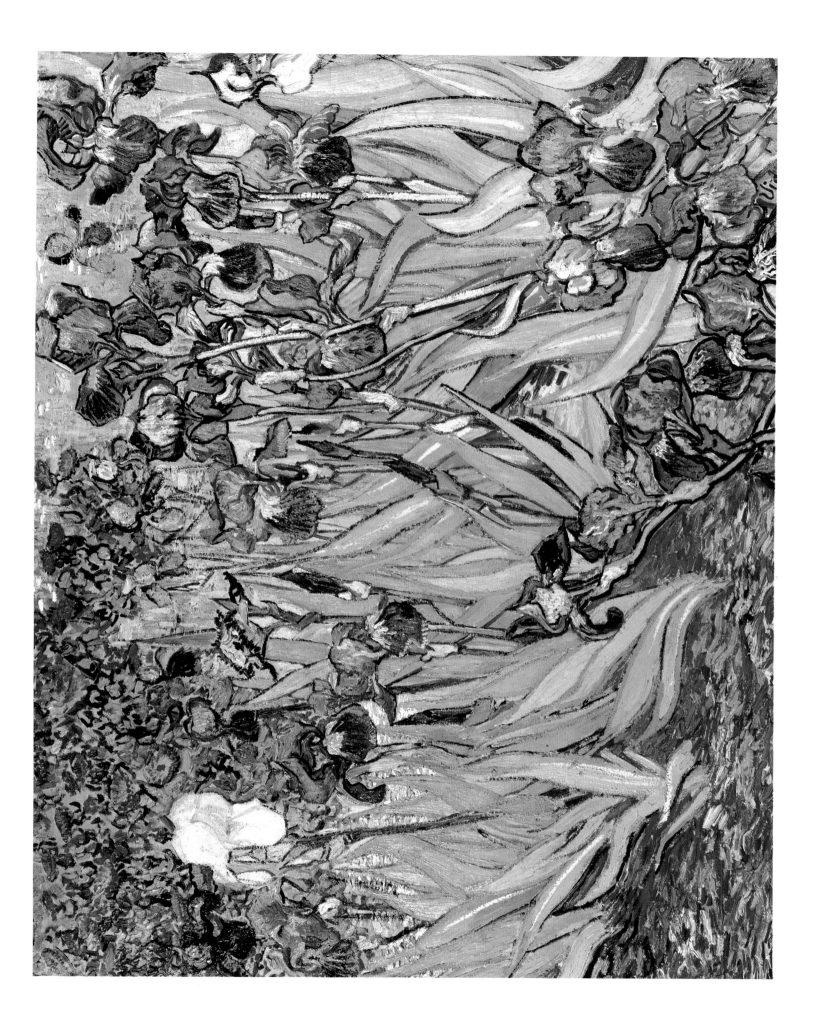

Painted Spring 1889, Saint-Rémy

THE ENCLOSED FIELD

Collection State Museum Kröller-Müller, Otterlo, The Netherlands

$(28\tfrac{3}{8}'' \times 36\tfrac{1}{4}'')$

A PAINTING disturbing to many eyes because of its unstable form and abrupt division of the landscape into the nearer and farther spaces. This risky, exceptional choice will justify itself as we come to know the work better. It belongs to van Gogh not only through the infusion of the landscape with sharply contrasting moods and forces, but in the energy of the execution itself, the marked rhythm of the patches of colour, the multiplied movements throughout space. In its daring unbalance we observe deliberate moves of stabilization through the dark green anchoring spot at the lower right, the horizontals of the red field at the upper left and the succeeding layers of mountains and buildings, and, above all, the attraction of the strangely coloured, off-centred sun.

The enclosed field—the space of the artist himself, a world of luxuriant growth and warm light, spotted with poppies, blue flowers and whites (but also with grave touches of black), a region of pure happiness—is steeply inclined, permeated by chaotic forces, and cut off from the world around it by a powerful rushing band of lavender-blue which joins diagonally opposite corners of the picture in two broken lines, each rendered still more unstable by the dark wavy shadow stream at its lower edge. In contrast, the far distance is cold in colour, even acid in places, and the yellow sky rising above the cold mountains is of a famished yellow; the sun of the same tone, outlined in deeper yellow, is pallid beside the luminous yellows of the enclosed field. The purple soil of the olive grove in the nearest region is equally cold. The bright yellow and red spots of the distance help to restore the balance—in their grouping they are clearly horizontal elements. The perspective too is used as a countering means. A succession of darker patches in the middle of the enclosed field—vague traces of furrows—forms a curved line symmetrical to the fence on the left and directed to the solitary tree on the mountain top above the red houses. This implied re-centring of the view has to compete with the sun beyond it, and there remains in the end that struggle between the vanishing-point and an adjacent distant object which is a recurrent feature of van Gogh's vision.

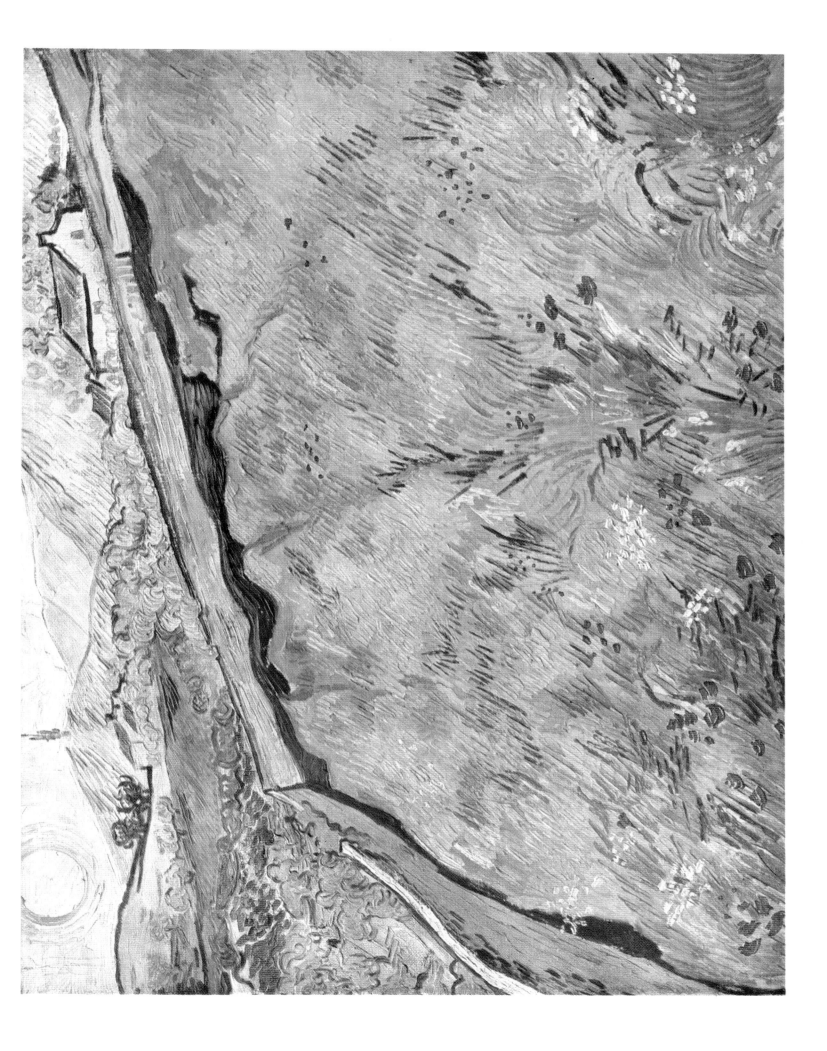

Painted June 1889, Saint-Rémy

THE STARRY NIGHT

The Museum of Modern Art, New York. Acquired through the Lillie P. Bliss Bequest

$$(29'' \times 36\tfrac{1}{4}'')$$

ONE of the rare visionary pictures inspired by a religious mood, it is characteristic of van Gogh as a representation of a transfigured night sky. An earlier version painted in Arles is more soberly lyrical, although prompted by a haunting desire to express his aspiration towards infinity in nature; there he added to the enchant-ment of the tiny stars the reflections of the city lights in the water and two lovers in the foreground. He dreamed also of a picture of the starry night "with a group of living figures of our own crowd".

When he returns to his theme at Saint-Rémy, after a period of crisis and religious hallucinations, the pressure of feeling, with its hidden tendencies and content, forces the bounds of the visible and determines the fantastic projections, the great coiling spiral nebula, the eleven magnified stars, and the incredible orange moon, with the light between its horns—a confused memory, perhaps, of an eclipse (he quoted Hugo: "God is a lighthouse in eclipse"), or an attempt to unite sun and moon into one figure; the tremendous flame-formed cypresses, the dark earthly, vertical counterpart of the dragon nebula, may also be an invention here, transferred from other landscapes, as a vague symbol of a human striving. The whole owes its immediacy and power to the impulsive, torrential flow of brush-strokes, the release of feeling along great paths. Every object and region has its own direction and rhythm, which contribute to the mobility of the vast whole. Van Gogh does not surrender passively to his exciting vision; he is able to detach himself as an artist and to seek an articulation which increases the emotional charge by opposing to its obvious effects other elements of contrast. Thus the town in the foreground is drawn in short, distinct, horizontal strokes, unlike the prevailing curves above. Its straight, angular lines were a correction of a first draft, in which these buildings, too, quivered like the rest of the space, in wavy forms. The small yellow lights in the buildings are all square or rectangular in shape, in contrast to the stars above. The thin church spire, its tip crossing the horizon, as the cypress top crosses the nebula, was another afterthought, replacing a series of redundant cypresses which echoed the passion of the dominant trees.

I have suggested in the text (pages 33-4) a possible element of apocalyptic fantasy within this work.

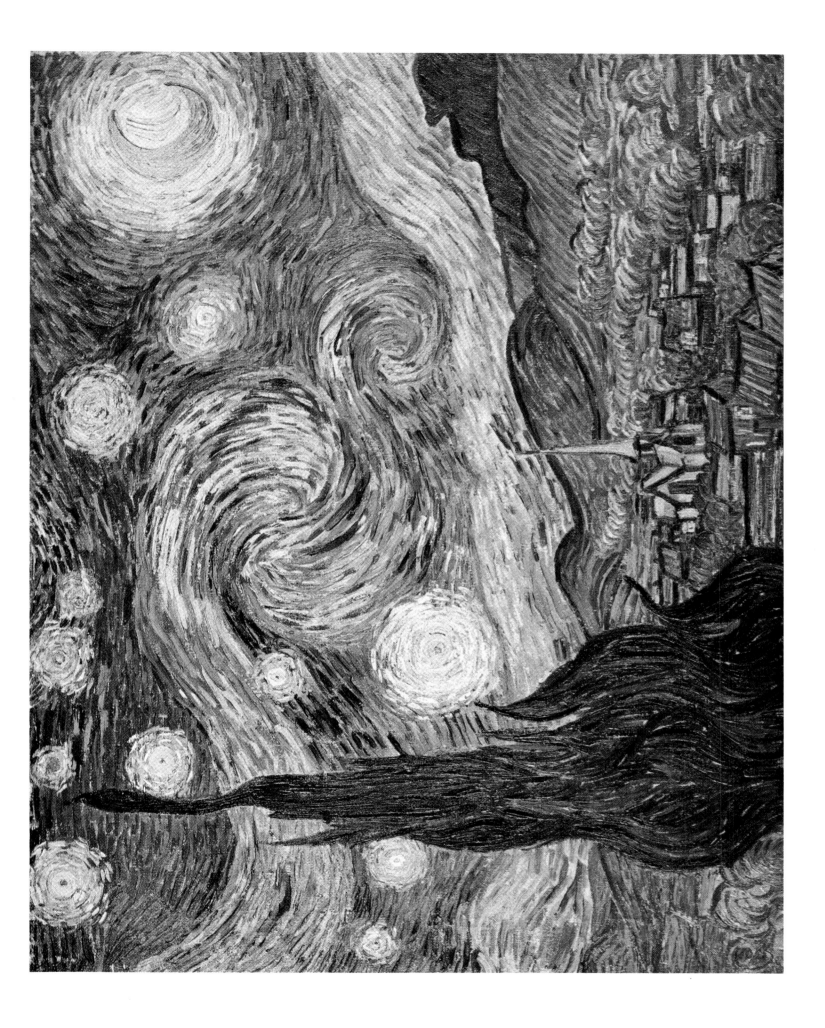

Painted September 1889, Saint-Rémy

SELF-PORTRAIT

Private Collection

$$(22\tfrac{1}{2}'' \times 17\tfrac{1}{8}'')$$

THE pervading blue, warmer, more violet, in the background, cooler in the clothes, shapes a mood that we cannot name or easily approximate in words, but of which the inward-pointing nature is clear. Not only is the blueness shared by the costume and the "abstract" surroundings, but the live brushwork forming this environment follows in its interwoven traces the changing edges of the head like a halo around it; at the same time it conforms in its vehement flow to the impassioned rhythms of the strokes that model the costume and the hair. Out of a dark hollow in the centre of this blue emerges the head with a glowing intensity—the crescent of the hair and beard is like the moon in *The Starry Night* (page 101). The face is mostly in shadow, a beautifully painted transparent shadow, rich in greens and blues, a dark film through which peer the red-rimmed eyes, probing and sad. Painting the hair, the moustache and beard, van Gogh forgets the shadow, giving to these parts their full intensity as exceptional luminous colours with interspersed greens, madders, and reds. A light shadow stream, bridged by a knot, rises from the upward-thrust, obtuse edge of the palette which echoes the face. Here the colours of the painting are laid out in a horizontal line, a surprising adaptation to the edge of the canvas, in defiance of the perspective of the palette itself. The brushes emerge from it like the lines of the smock, forming a fanwise succession from the violet patch below to the wedge of background above—triangular shapes repeated and inverted in the areas beyond, and cul-minating in the pathetic region of the right eye. The head turned to its right, together with the palette, gives to that side a more abrupt, constricted, tense quality; the other half is rounded and continuous in its forms. At the same time van Gogh, with an approach to classic sensibility in his new curvilinear style, has continued the hollow edge of the face in the line of the right shoulder, pro-ducing by this larger crescent form a hidden symmetry of the two sides of the head and shoulders in a three-quarters pose.

This portrait in its jewelled perfection and depth of feeling permits us to measure van Gogh's great advance since the last of his Paris portraits (page 49); it corre-sponds to a deeper self-insight as well as to an enormous growth in power of expression.

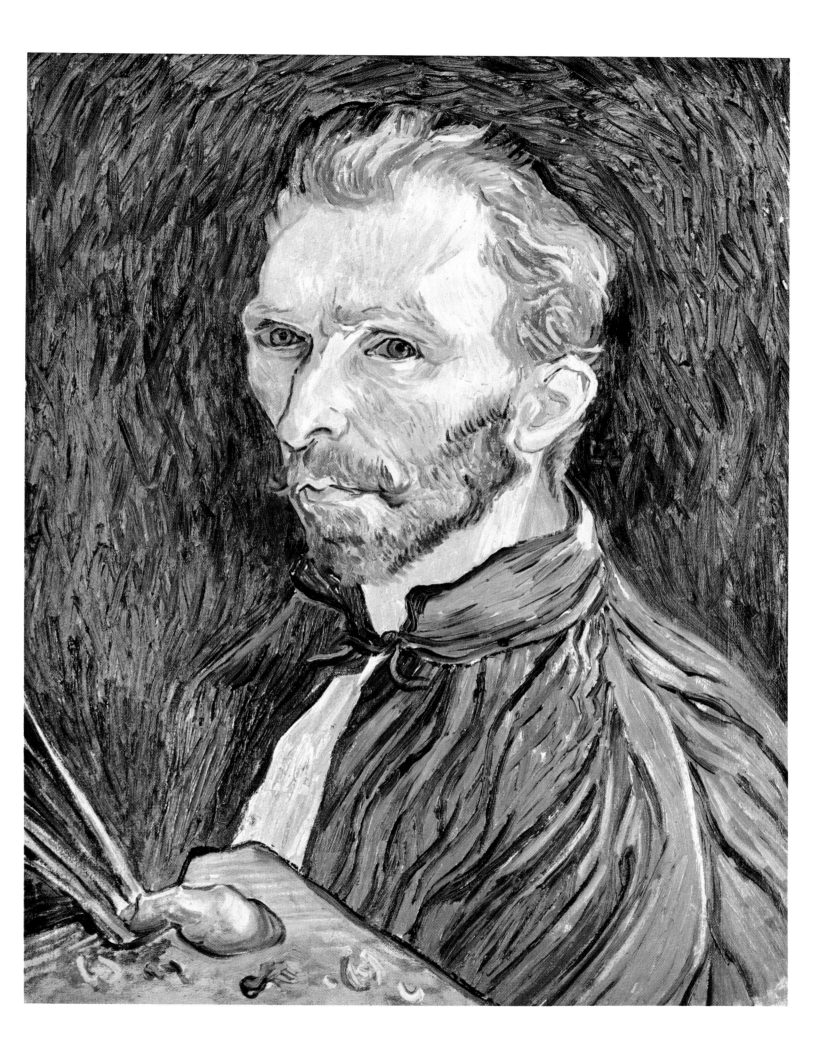

Painted September 1889, Saint-Rémy

PIETA (AFTER DELACROIX)

National Museum Vincent van Gogh, Amsterdam

$(28\frac{3}{4}'' \times 23\frac{3}{4}'')$

DURING his convalescence at Saint-Rémy, Vincent was often occupied with religious thoughts. It was at this time that he painted a number of biblical themes; with characteristic sincerity, he did not conceive the religious figures from imagi-nation—for he was no longer a believer, although he admired Christ as the greatest example of self-sacrifice and love. His religious pictures were copied and transposed into colour from reproductions or prints of older masters, Delacroix and Rembrandt. In the choice of the subjects, the motive of van Gogh's religious paintings is evident: the dead Christ in the arms of the Virgin, the Raising of Lazarus, the Good Samaritan—all these represent a suffering figure and intimate a future salvation.

Copying Delacroix's studied composition and figures, van Gogh translates the lines and colours into his own more awkwardly pathetic and intense language, breaking the silhouettes, multiplying the visible brush-strokes, and accenting the span of yellow and blue. The shadow of the Virgin's clothes is of an absolute dark blue, like his most visionary and tempestuous skies. Christ's shroud, in contrast, is whitish yellow, daringly lined with blue shadows. The same dramatic opposition of yellow and blue divides the sky into two great zones. The pink and green in Christ's flesh are correspondingly repeated in the rocks at the right. The head of Christ, with reddish beard and green shadows, recalls van Gogh's self-portraits, through the colour alone; the features have another form.

In the more jagged and intense movement of the whole, in the contrast of broken and sinuous forms, and in the wavy lines that meet in a prolonged pointed tip like a leaf—as at Christ's left shoulder and the ground—we recognize van Gogh's conversion of Delacroix's resilient curves. But this copy also permits us to see the kinship of his painting at Saint-Rémy with Romantic and Baroque art.

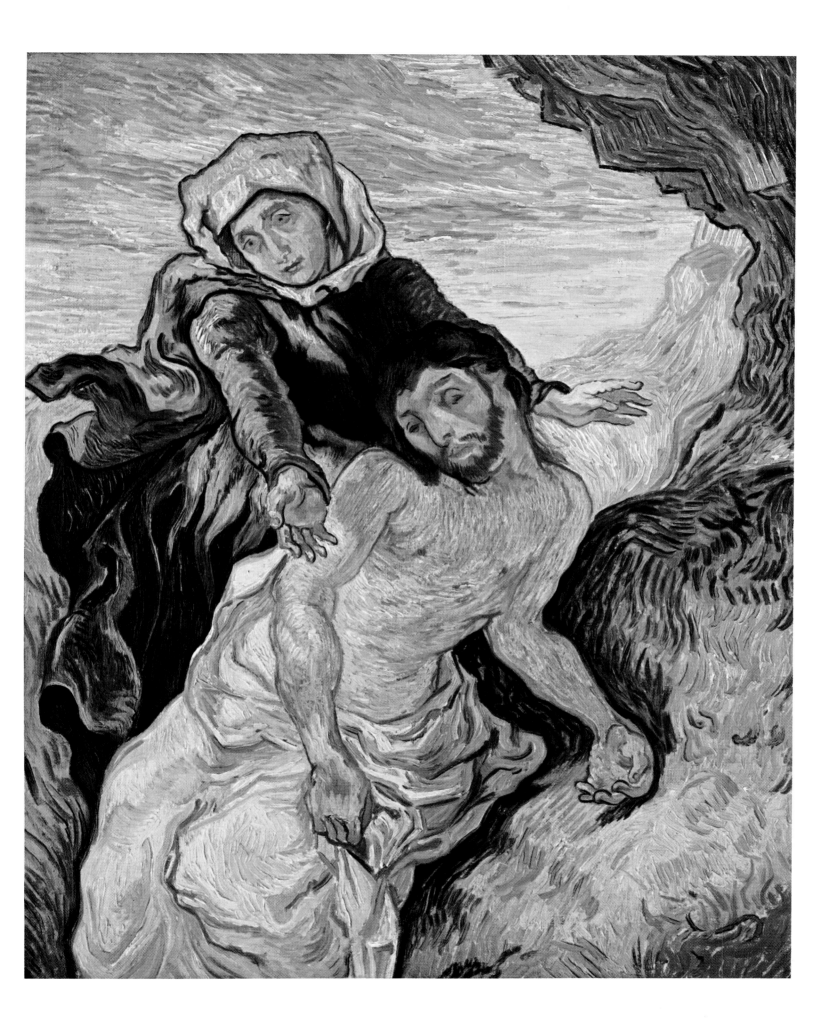

Painted September–October 1889, Saint–Rémy

OLIVE ORCHARD

Collection State Museum Kröller–Müller, Otterlo, The Netherlands

$\left(28\tfrac{3}{8}'' \times 36\tfrac{1}{4}''\right)$

WHILE in the asylum in Saint–Rémy, van Gogh received from his friend, Emile Bernard, a letter describing his new painting of Christ in the Garden of Olives. He replied that he would rather paint the olive trees just outside his window than the imaginary olive garden of Christ's Agony. He believed that reality was the only source of strength, although in his torment van Gogh's thoughts often led him back to the religious ideas of his youth.

His painting of the olive orchard is fervent, carried along by a single wave of intense feeling, which traverses the entire canvas, imparting the same irregular undulation to the earth, the trees, and the sky. Completing the work, the painter signs his name on a curve in the hollow of the ground.

With all this excitement of the brush–strokes and the larger forms they weave, the painting is subdued and mellow in colour—in part because of the narrow range of brightness in the three great masses of blue, green, and ochre, that make up the work. Contrasts are reduced and softened; there is no fully saturated colour, at least in large mass; a quality of reverie is cast over all this restlessness. The balance of cool and warm and the division of the canvas into almost equal close–jointed areas of different hue, have a calming effect.

The tones of earth, sky, foliage, and tree trunks—a concert of four distinct instruments—are harmonized by the recurrence of the blue of the sky in the tree trunks and branches, and of the greens and greys of the trees in the shadows of the earth. The vigorous lines of the branchings of the trees return in the beautiful arabesque of the softer silhouettes of the sky.

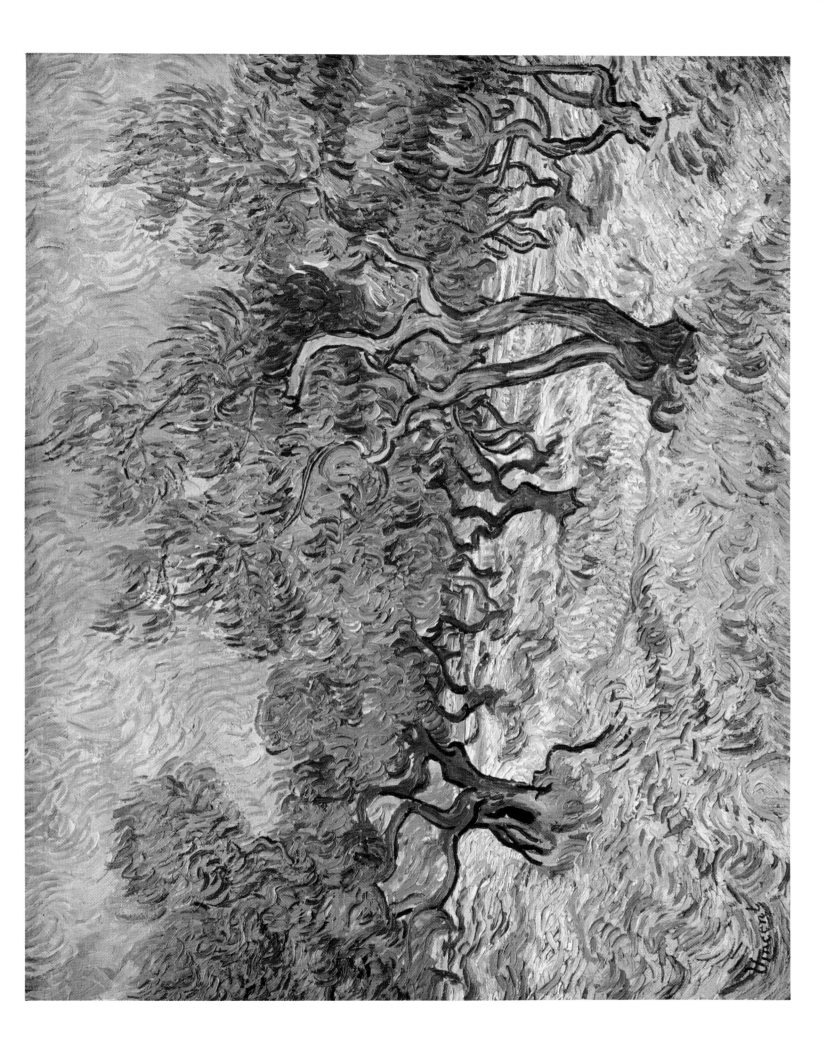

Painted June-July 1889, Saint-Remy

LANDSCAPE WITH OLIVE TREES

Private Collection

$(28\frac{1}{2}'' \times 36\frac{1}{4}'')$

VAN GOGH'S passionateness fills the entire landscape—ground, trees, mountains, clouds—with a tumultuous heaving motion. It is more powerful and imaginative than anything in later Expressionist art, which proceeded from a similar, emotionally charged vision of nature. It is also more attached to the real, for in the common movement that seems to issue from an underlying force, overwhelming all objects, these retain their individuality, their unique rhythms. It is the decided character of each horizontal zone of this turbulent work that keeps the picture from succumbing to the dullness of chaos, which so often results from an artist's immersion in pure feeling. The visionary cloud, with blue and yellow streaks and wavy outline, vaguely organic—one can see in it a wraith-like mother and child; the fantastic rugged silhouette of the mountain with the perforated rocky mass, like a ruined castle—these are new forms of great power. The colour too shows an ordered variation, striking in its freshness: the light cloud against the cold greenish blue sky; below, the warmer, light greens of the olive trees against the dark blue of the mountains; and in the lower half of the work the churning sea of the earth with coiling bands of light and shadow, of yellow, blue, and green. Characteristic of the drawing, besides the extraordinary length of the wavy lines—van Gogh compared the lines with those of old woodcuts—is the depth of their hollows. At first view overpowering in its sustained movement, the landscape offers to continued meditation a surprising range of qualities: the soft floating cloud and the hard rocks; the bland uniformity of the sky colour and the fierce changing contrasts of the space below; the furious storm of the brush-strokes in the trees and the rhythmical waviness and clarity of the mountains; the uniform local colour of sky, mountains and trees and the wild mottling of the earth. In all these, a pervading luminosity, from the distant cloud to the earth beneath the olive trees.

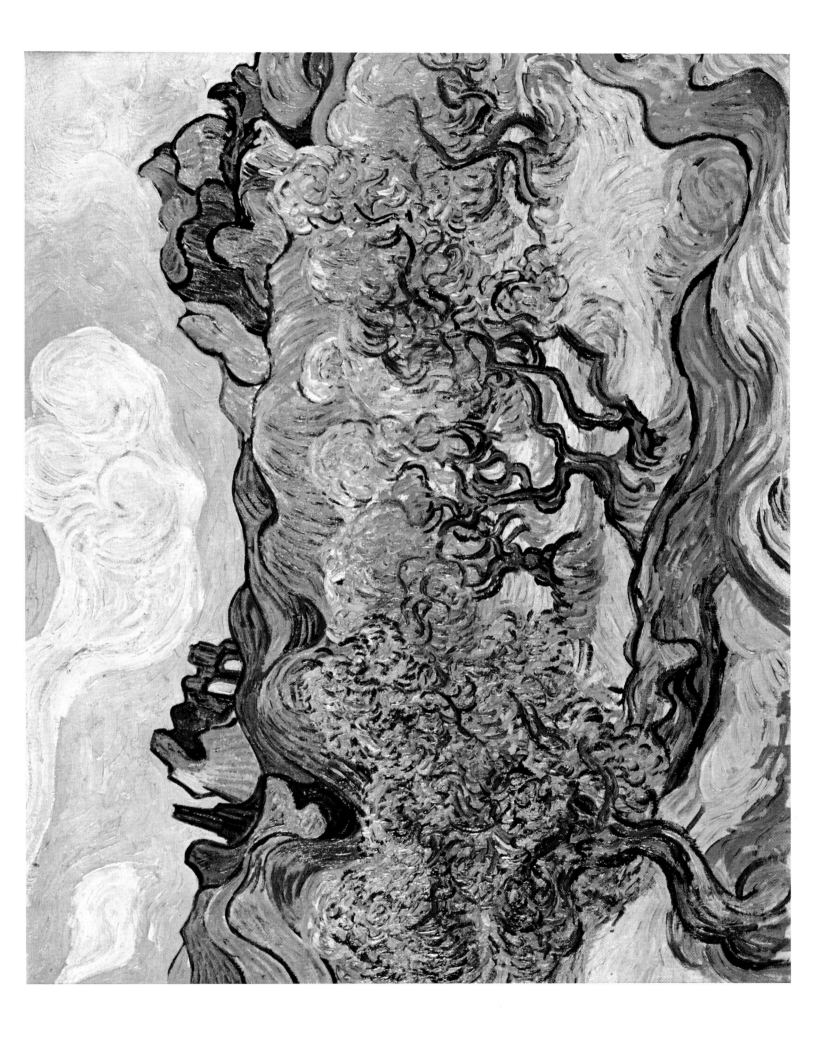

Painted September 1889, Saint-Remy

WHEAT FIELD WITH CYPRESSES

The National Gallery, London

$(28\frac{1}{2}'' \times 36\frac{1}{4}'')$

ALTHOUGH restless beyond measure, with few straight lines, this landscape is one of the most classic in conception among van Gogh's works. It is built up in great bands that traverse the entire space. The tall dark cypress trees at one side offer a powerful contrast to the prevailing horizontals, which they resemble in form. The oppositions of warm and cool, the proportioning of parts, the relative height of sky and earth on the two sides, the horizontal intervals which we can measure on the silhouette of the distant mountain, twice broken by trees—all these are perfectly legible and well-balanced.

It is a landscape in which the painter's perceptions of nature and his intensity of feeling are equally pronounced. The glowing wheat field, the olive trees of subtle grey in which all the colours of the picture seem to be mingled, the shaggy wavering cypresses, and the turbulent mountains, have been wonderfully observed, and the light that fills this space has a vivid actuality for our eyes. The brightness emanating from the cold sky and the warm earth is realized as much through the local colours as through the play of light and shadow—van Gogh is free with the latter, and hardly aims at consistency on this point.

It is mainly in the sky that his stormy emotion begets strange shapes, which carry us beyond nature. These contorted, monstrous forms, twisted, coiling, in places congested and unclear, evoke images of supernatural combats. The soft blues, lilacs, whites and greenish tones of this sky are repeated in lesser mass in the earthy landscape below, and the fantastic heavens are finally absorbed into the familiar, natural world. The latter, too, is pervaded by wild energies, demanding release; but these do not deform the objects so much as they intensify them. Here the impulsive ecstatic brush, marvellous in its fluency, is faithful to the structure of objects.

The duality of sky and earth remains—the first light, soft, rounded, filled with fantasy and suggestions of animal forms, the earth firmer, harder, more intense in colour, with stronger contrasts, of more distinct parts, perhaps masculine. Or one might interpret the duality as of the real and of the vaguely desired and imagined. Connecting them is the single vertical, the cypress trees, as in *The Starry Night* (page 101), of which this painting is in other ways the diurnal counterpart.

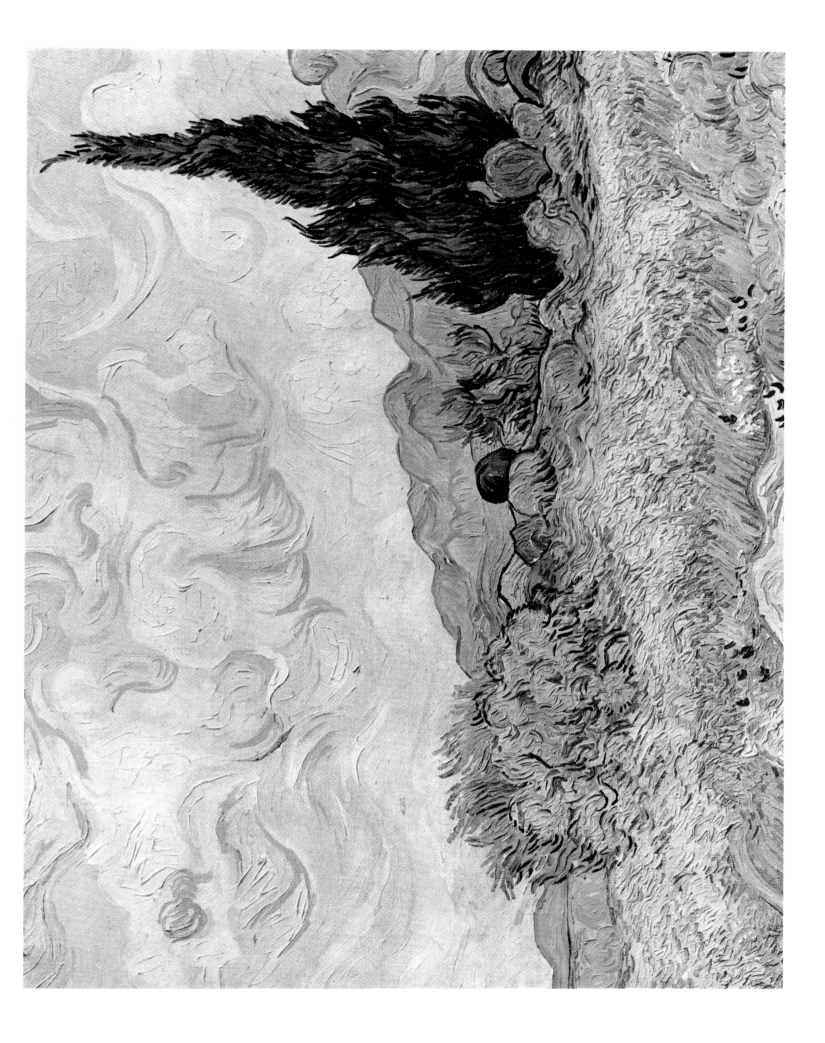

Painted November 1889, Saint-Rémy

THE ROAD-MENDERS

The Cleveland Museum of Art. Gift of Hanna Fund

$(29'' \times 36\frac{1}{4}'')$

A STARTLING conversion of the familiar Impressionist street scene—Manet had already painted the men at work paving. Here in the midst of a street torn up by excavation, nature reasserts itself with an overwhelming raging energy in the giant tree trunks and branches and the masses of fiery foliage, transforming the pedestrians' intimate path into a world of apocalyptic portent, neither natural nor urban. In this narrow space where the limbs of the monstrous plane trees reach out frantically like inverted roots into an upper region of flame, the other objects—the buildings, the road, the figures walking or at work—retain their everyday mediocrity; yet when isolated as fragmentary vistas cut out between the arched contours of the trees, they take on a correspondingly strange and charged, irregular aspect. Here as in other paintings of this time the perspective is a source of action, and is wedded to the unstable patterns of objects. The sharp diagonal of the street (really the diagonal of the spectator's glance), with its contrasts of unordered wavy heaps of sand and regular cut stone, also rich in abrupt zigzags, the contrast too of cold lights and darker warms—this great diagonal stream in depth opposes and sustains the turbulence of the branches above and the tormented pointed archings of the tree silhouettes that enclose the slanting vistas of the buildings across the street. Without large areas of simple colour, without a clear focus or points of rest, the harmony of this picture seems a miracle. It is for the first glance a chaos, a storm, not only in the lines but in the complicated spotting of tones which van Gogh seeks out and multiplies in the foremost tree whose enormous trunk is wreathed with winding passages of contrasted and mottled colour. And even after we have discerned a grave harmony in the close stepping of the local colours of the objects themselves—from the warm tones of the roadway, the street, the buildings with the green doors and shutters, and the yellow foliage, to the greyer, broken tones of the rest—we are brought back forcibly to the rest-lessness and violence of the whole. The contrast of the distant burning yellows and the cold, neutralized tones of the trees and the foreground gives an original savour to the whole.

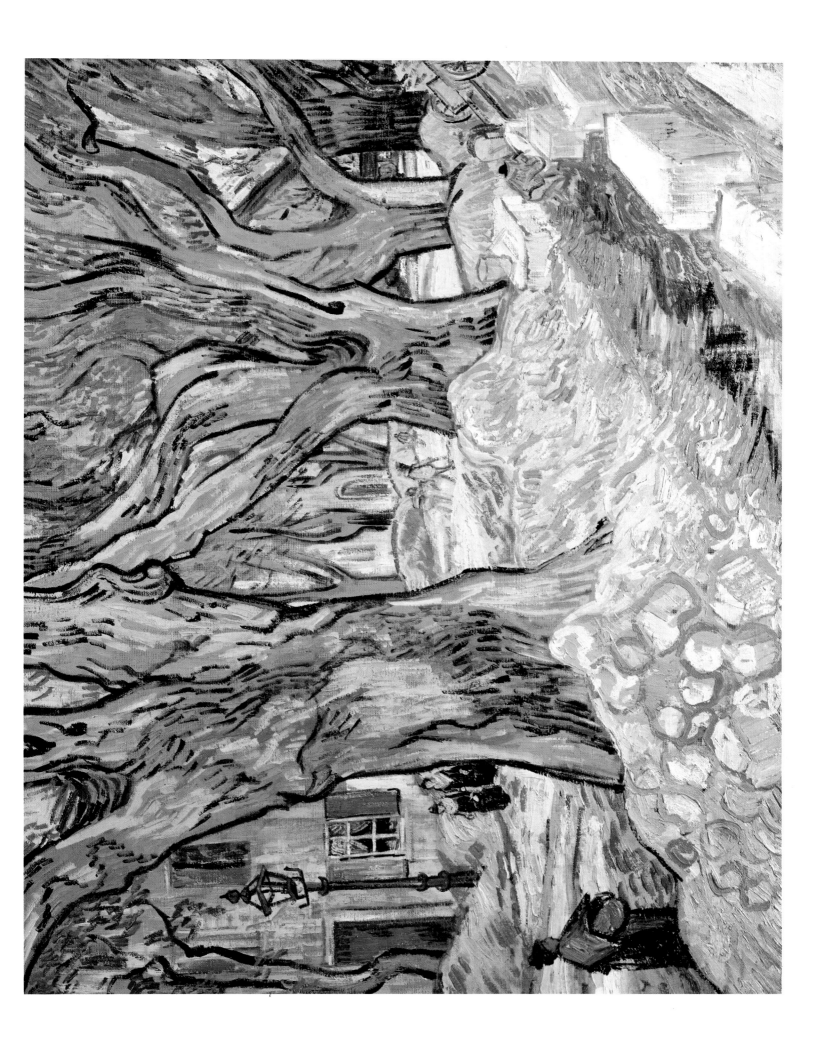

Painted November 1889, Saint-Remy

LANDSCAPE WITH PLOUGHED FIELDS

Whereabouts Unknown

$$(28'' \times 35\tfrac{5}{8}'')$$

A LANDSCAPE with two centres: the observer's viewpoint, indicated by
the violet furrows converging hurriedly to a point behind the dark trees at the
left horizon, and accompanied by rushing streams of contrasted, coloured strokes
in the field; the second is the great sun at the right, with its concentric rings of
yellow and orange strokes, reaching beyond the horizon and the frame, and
complementary to the violet tones of the other vista and to the blues in the
mountains below.

In this rivalry of centres we feel some relation to human conflict, a tension
between the self and its goals. It has also a pictorial value as a dynamic means
of expression and design. The two opposed schemes, the convergent and the
concentric, are broken and varied, and penetrate each other in details of colour
and line, which also intensify the living reality of the scene. An irregular diagonal
path moves across the field, cutting the main furrows and anticipating in the
observer's foreground space the rhythms of the distant shadows and hills. These
long wavy forms are in turn contrasted with the straight lines of the enclosing wall.

With all these vigorous oppositions, the colour is of an enchanting subtlety.
Van Gogh has accepted the magic of sunrise colouring as a model and a source,
and tried to capture its variations and poetic suggestiveness in pigment tones. In
the yellow-green foreground field, he introduces long violet strips in the furrows
and smaller touches of violet, blue, and purple between them. In the distance,
dark green and purplish reds play against violet and blue. And in the sky, within
the prevailing luminosity, yellow gives way, at the sides, to cooler tones. Through-
out, the colour retains a woven texture; it is a continuous interplay of tiny contrasts
and possesses, besides the energy of flashing points, the dynamism of great currents
of coloured particles moving in a single direction, varied from object to object,
from region to region of the space.

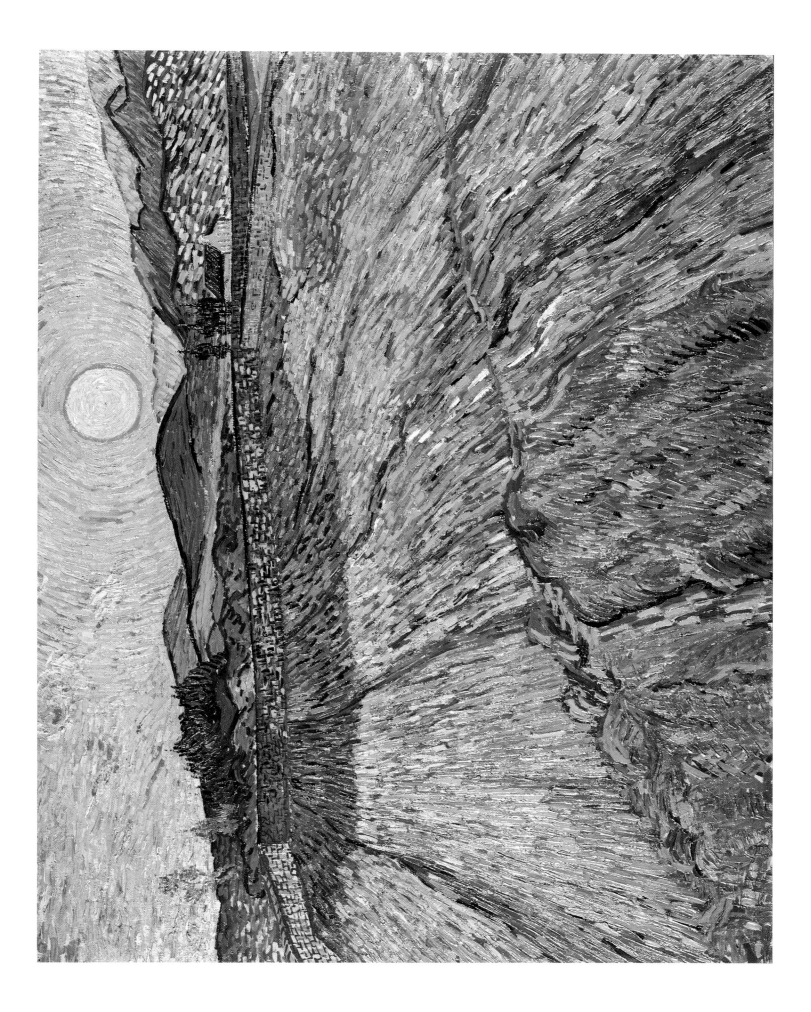

Painted May 1890, Saint-Rémy

THE GOOD SAMARITAN (AFTER DELACROIX)

Collection State Museum Kröller-Müller, Otterlo, The Netherlands

$(28\frac{3}{4}'' \times 23\frac{5}{8}'')$

AT Saint-Rémy van Gogh made numerous copies after reproductions or prints of Millet, Rembrandt, and Delacroix. He likened these to interpretations of music by a violinist. The colour was his own; based on memory of original works of these masters, the copies were at the same time a free interpretation infused with his own feelings and the inevitable peculiarity of his drawing and brushwork. "Heaps of people do not copy", he wrote, "heaps of others copy—I started it by chance and I find that it teaches me things and above all it sometimes gives me consolation. And then my brush goes between my fingers as a bow would on the violin and absolutely for my pleasure."

In the choice of the theme of the Good Samaritan we may see his longing for friendship and deliverance. He had given himself impulsively to others, and he had felt his own abandonment.

Delacroix appealed to him as a patron saint of his art through whose writings he had first become aware of the problems and possibilities of colour. He looked up to him indeed as the Newton of the science of colour. And when in Arles he had broken with Impressionism in his search for greater intensity of colour, van Gogh thought of his advance in painting as a return to the principles of Delacroix.

The subdued richness of colour—very different from the extreme contrasts in the earlier copy of Delacroix's *Pietà*—is a happy reminiscence of the French master, but it corresponds also to the mellowness and prevailing key of much of Vincent's work in Saint-Rémy. The stronger notes of colour, Delacroix's characteristic red and blue, are set in an ambience of more neutral and brownish tones, finely harmonized through stepped intervals of warm and cool, of light and dark.

To the original rhythms of Delacroix's passionate drawing, van Gogh adds the torrential flow of parallel brush-strokes. Arabesques which in Delacroix are sinuous, bulging curves are rendered by van Gogh as more broken and awkward lines, with something of the strain and homeliness of his Dutch drawings.

We have few examples in modern painting of this devoted translation of the works of older artists—a practice common in the tradition of Western music.

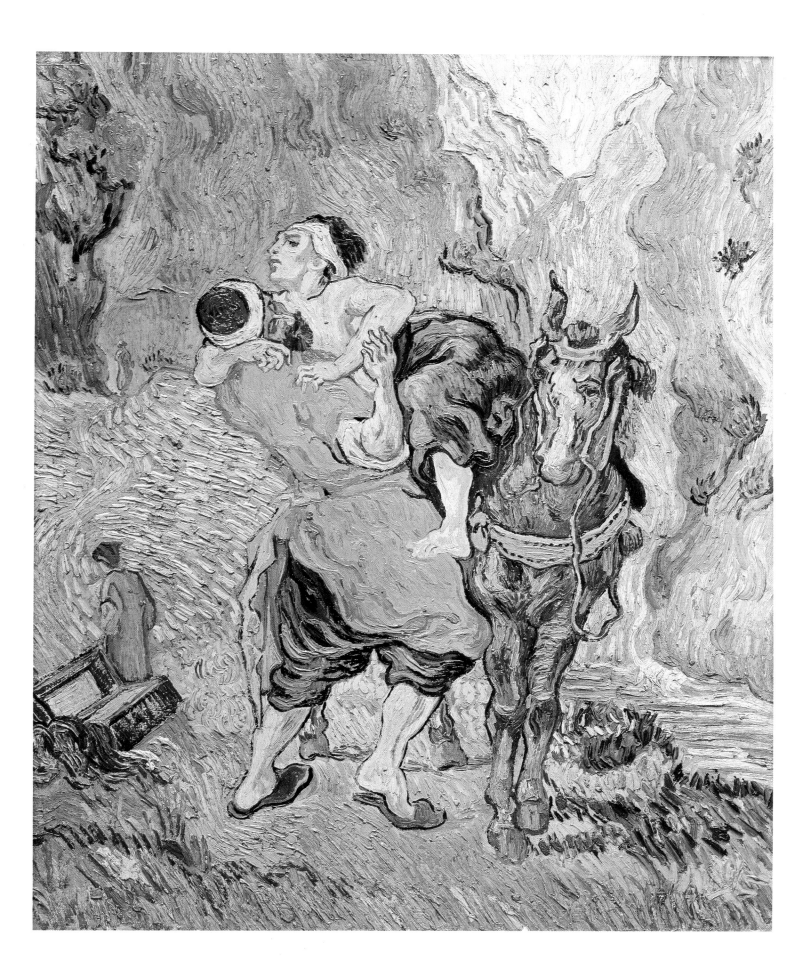

Painted September 1889, Saint-Remy

SELF-PORTRAIT

The Louvre, Paris

$(25\frac{5}{8}'' \times 21\frac{1}{4}'')$

THIS, the last of his self-portraits and one of the greatest, was painted only months before his death.

The compulsive, restless all-over ornament of the background, recalling the work of mental patients, is for some physicians an evidence that the painting was done in a psychotic state. But the self-image of the painter shows a masterly control and power of observation, a mind perfectly capable of integrating the elements of its chosen activity. The background reminds us of the rhythms of *The Starry Night* (page 101), which the portrait resembles also in the dominating bluish tone of the work. The flowing, pulsing forms of the background, schemata of sustained excitement, are not just ornament, although related to the undulant forms of the decorative art of the 1890's; they are unconfined by a fixed rhythm or pattern and are a means of intensity, rather, an overflow of the artist's feelings to his surroundings. Beside the powerful modelling of the head and bust, so compact and weighty, the wall pattern appears a pale, shallow ornament. Yet the same rhythms occur in the figure and even in the head, which are painted in similar close-packed, coiling, and wavy lines. As we shift our attention from the man to his surroundings and back again, the analogies are multiplied; the nodal points, or centres, in the background ornament begin to resemble more the eyes and ear and buttons of the figure. In all this turmoil and congested eddying motion, we sense the extraordinary firmness of the painter's hand. The acute contrasts of the reddish beard and the surrounding blues and greens, the probing draughtsmanship, the liveness of the tense features, the perfectly ordered play of breaks, variations, and continuities, the very stable proportioning of the areas of the work—all these point to a superior mind, however disturbed and apprehensive the artist's feelings.

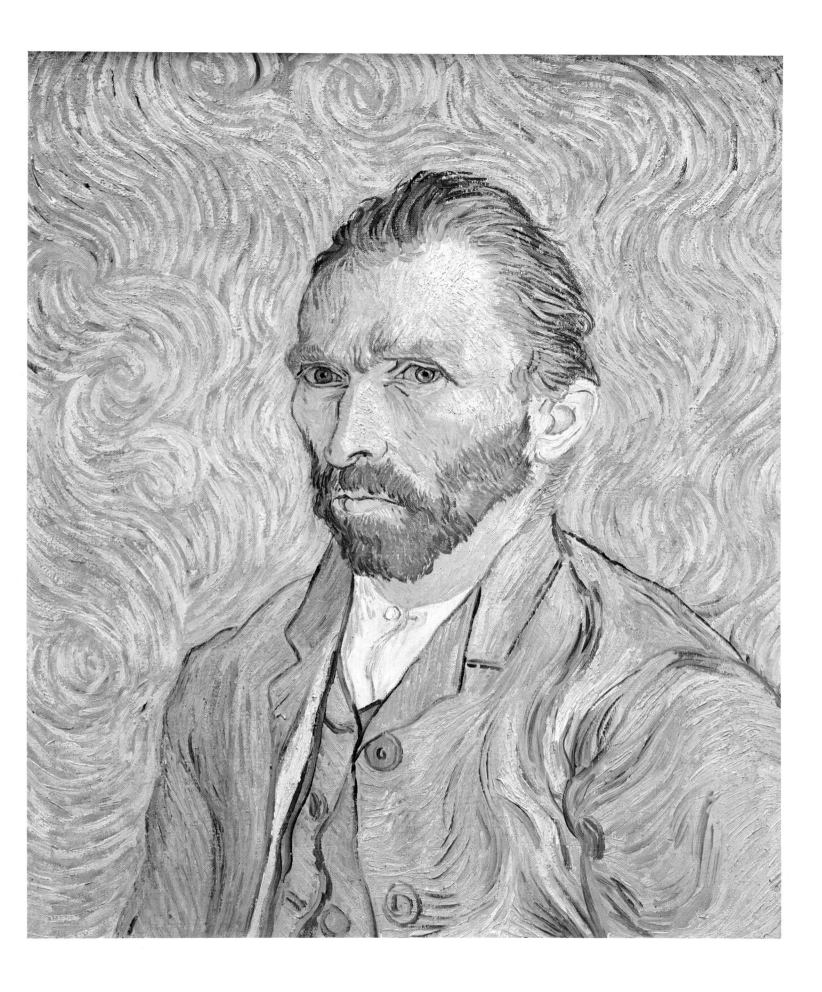

Painted June 1890, Auvers

PORTRAIT OF DR. GACHET

Private Collection

$(26'' \times 22\frac{1}{2}'')$

DR. GACHET to whom van Gogh came for medical care was also an amateur painter and engraver and a friend of the Impressionists. His face stirred van Gogh as another self, with a malady like his own and "the heart-broken expression of our time".

In painting him, van Gogh returned to devices he had used in *L'Arlésienne* (page 89)—the pale face among intense colours, the contrasting table with yellow books, and the hand raised to the head. But in that picture there is little study of the individual, while Dr. Gachet's portrait is a profoundly searching image of a man in which the entire painting is invested with his qualities. They are also van Gogh's qualities, as the artist implied in comparing it to his recent self-portrait (page 119). As in the latter, two modes of portrayal are combined, the probing of the features in their tiniest inflections, and the free creation of an expressive structure of lines, colours, and areas which convey a sensed mood of the person. Here they are wonderfully united, for that original play of colour and arabesque —they resemble late landscapes of van Gogh—issues from the head and hands, in extension of their hidden movements of feeling. The rich blue, with its passage from deep to lighter tones, is an affecting intensity and hue beside the subtle pallor of the face in which are set the withdrawn blue eyes, and the luxuriant growth of coiling lines, of an amazing fluency and life, follows in its long axis the pathetic inclination of the man, a natural posture which communicates the inner tone of this sensitive, discouraged soul. The restless lines of the background parallel the undulations of the cap, the shoulder, and the features; the recoiling curves of the jacket are in the closed right hand and in details of the asymmetrical face; the pointed white spots of the collar and sleeve and the dark lance-shaped corner between the right hand and the jaw (repeated in the leaves and flowers), may be found in the pointed eyes and lips; and the branching folds at the left arm reproduce the structure of the hand nearby. This dynamism of the edges is sustained in the vibrant brush-strokes that follow or connect the contours. They activate the surface of the costume and background and model the jacket in their rounded course; in the background they follow the tendency of the figure more than the outlines of their own fields.

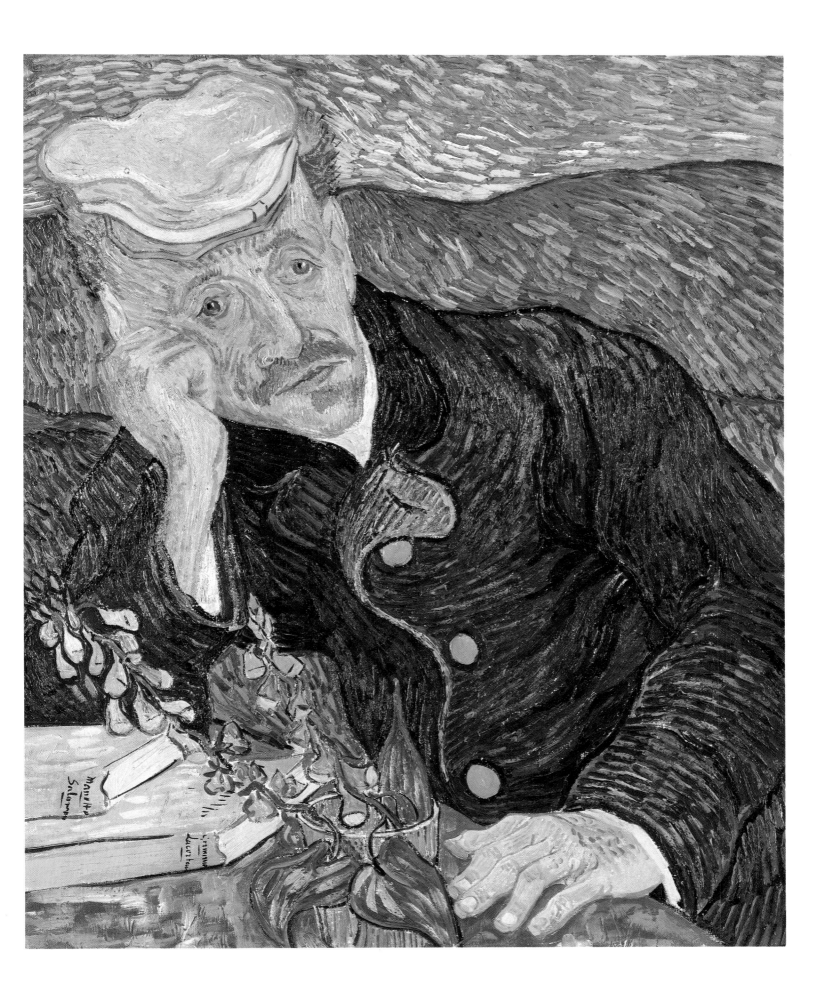

Painted June 1890, Auvers

UNDERGROWTH WITH TWO FIGURES

The Cincinnati Art Museum. Bequest of Mary E. Johnston

$$(19\tfrac{1}{2}'' \times 39\tfrac{1}{4}'')$$

THIS peaceful painting of the woods, with a man and woman walking through the thick undergrowth, is a great surprise, when seen among the high-strung works of his last period. It is unusual, not only in the quiet harmony of white, yellow, speckled green and lilac, but also in the predominance of vertical lines. These are not architectural in feeling—since there are no corresponding stressed horizontals—but lyrical, a community of friendly presences, shaped like walking figures, upon a soft yielding ground with scattered touches of yellow and white flowers. It is as if all the coiling forms had been straightened out, and the crisscross networks unravelled, leaving only a simple succession of vertical lines and a shapeless ground. Not completely unravelled, however, for there is still a trace of the dramatic perspective of his more impassioned works in the divergent vistas through the woods, proceeding from the central foreground tree; but the pull of the open diagonal path at the left is not countered by similar flights elsewhere. On the right, the endless forest asserts itself, expanding in all directions without impulsive accents or paths.

Painted June 1890, Auvers

PEASANT GIRL

Private Collection

$(36\tfrac{1}{4}'' \times 28\tfrac{3}{4}'')$

THE conception of this portrait is pure van Gogh. Somewhat stiff, arranged, self-conscious, it is a search for the natural human being in its own milieu. Sitting in the high wheat, the young peasant girl bears the natural tones of the field in her apron, her hat, and her skin, while her cheeks are ruddy like the poppies nearby. Against the less saturated warm tones of the wheat and the apron, the pure blue of the blouse, with its multitude of tiny red spots, stands out in jewel-like brilliance. We leap then beyond the head to the golden yellow of the hat and its orange-brown shadow, for warm counterparts; and on this hat the light clear blue of the ribbon is a related fresh contrast. Underneath the sophisticated, but somewhat abrupt colouring, patterns, and textural variations of this portrait we rediscover the driving sincerity and robustness of the early brown peasant-paintings of van Gogh.

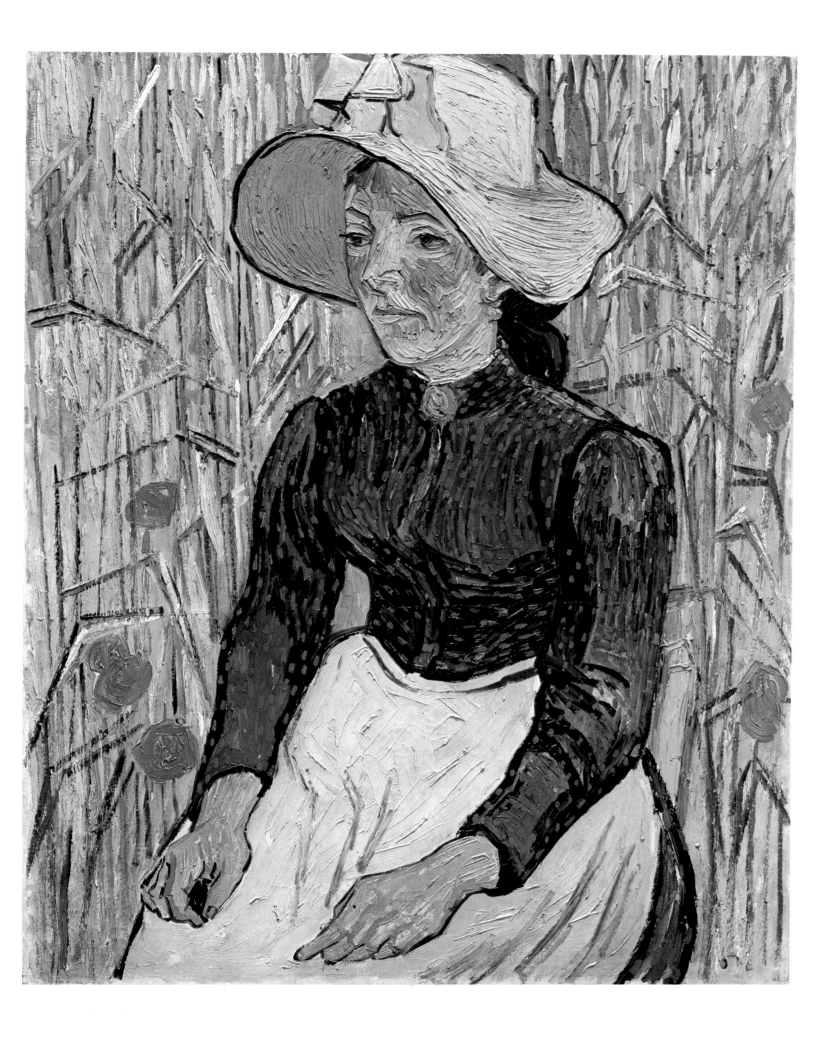

Painted July 1890, Auvers

STAIRWAY AT AUVERS

The St. Louis Art Museum, Purchase

(20″ × 28″)

In its broad symmetry, pairings, recurrent arabesques and wavy, ribboned patterning, this is one of van Gogh's pictures closest to ornament and the popular decorative taste of the 1890's, the so-called *art nouveau*. It recalls this art too by its flatness, reduced substance and general lightness of colour. Compared to other paintings by van Gogh, this has a tinted quality, because of the amount of white and dilute tones of yellow, green, and blue. A scene of many convergences and encounters, focused upon a central region at the foot of the steps, it has no real dominant; the general effect is governed by the hectic movement of unsteady diagonal lines imposed upon objects of unlike character. The repetition of this restless theme is so impulsive, however, and contains so many interesting varia-tions, that the painting soon loses that aspect of ornament and becomes a work of intense passion and concentrated seeing. We discover contrasting straight lines in the buildings, stabilizing horizontals and verticals, the important red roofs, and numerous touches like the yellow hats, the yellow doorway, and the dark windows (which recall the women's skirts)—deliberate oppositions to the prevailing instability, yet not altogether opposed to it in their own spottedness. The undulating forms too have their individual character. Between the house and the steps, they define a long, coiling triangular shape which reminds us of the cypress and the road in a previous work of an ecstatic, visionary quality (frontispiece). Here as in earlier paintings van Gogh practises that exchange of tones between far separated parts of the space (and between neighbouring objects in different planes) which is one of his most effective unifying means. The same white tones with notes of blue and green occur in the distant house, in the dresses of the two girls in the foreground, and in the road and wall which they connect. In all this excitement of lines and spots there is also a note of buoyant gaiety and delight.

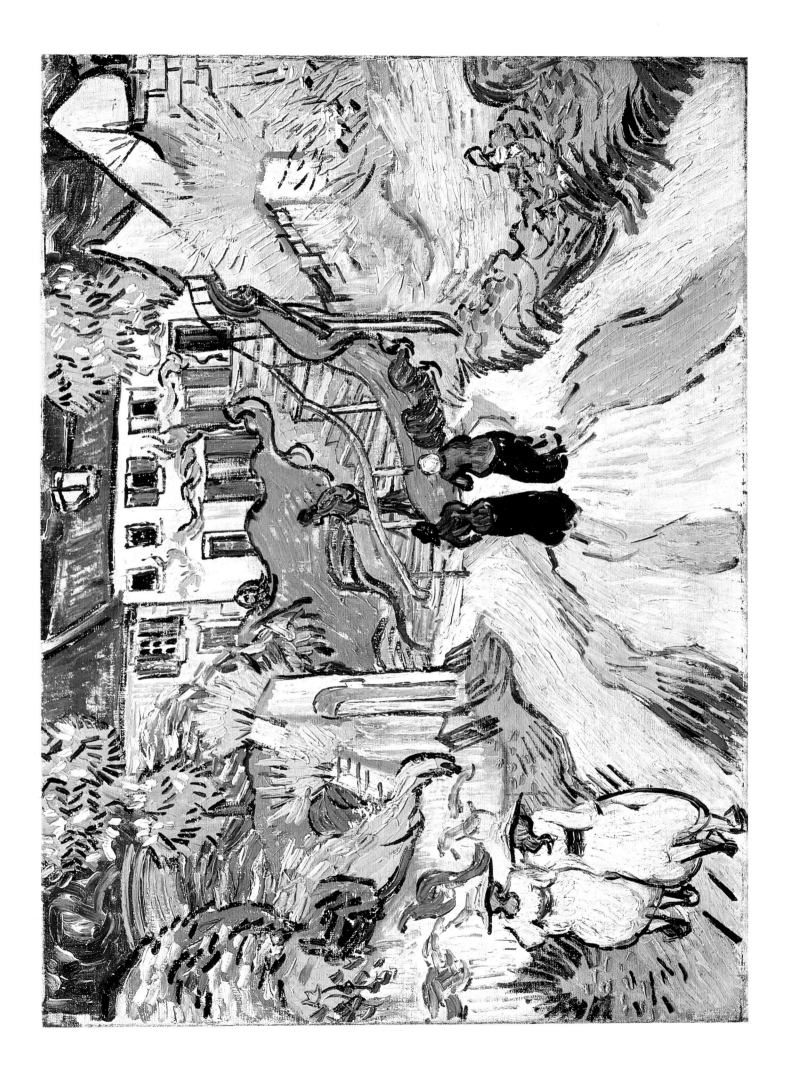

Painted June 1890, Auvers

MADEMOISELLE RAVOUX

Private Collection, Switzerland

$(26\frac{3}{8}'' \times 21\frac{5}{8}'')$

T H E strict profile and simple placing of the shy figure recall the precise, impersonal Italian portraits of the fifteenth century. The drawing here, relatively unimaginative in detail, although it builds up an imposing compact form, is less important than the pervading blue, an ultimate blue of wonderful richness, depth, and jewellike luminosity, new to the art of the time. This blue has a beauty akin to that of blue stained glass and mosaic, where it is allied with a similar simplicity of form. But unlike these older blues, van Gogh's is not merely a background colour; applied also to the dress and dominating the face (which is doubly submerged—through its pallor and weakened profile), it is the dominant quality, the very idea, of the entire painting, compulsive in its excess and leading us, through its omnipresence and dark intensity, to a mystical, ecstatic mood. Unfamiliar and imaginative as it is, this blue depends for its final effect on the Impressionist method of vivifying colour by the tangible play of touches, which produce a perpetual flicker within this dark recessive tone. These touches, like mosaic cubes, are patterned material units; each region has its own clear arrangement in contrasting directions which reinforce the major forms as distinct parts of a single darkly glowing whole. The method retains, however, the marks of the hand and its impulse, in the free variation of the strokes; and the blue itself is modified in tone by cooler blues on the bodice and sleeve, by violet touches on the skirt. The general vigour of execution, the abrupt breaks of contour, the rugged drawing of the chair and the girl's back, introduce a masculine energy into this ecstasy of endless blue.

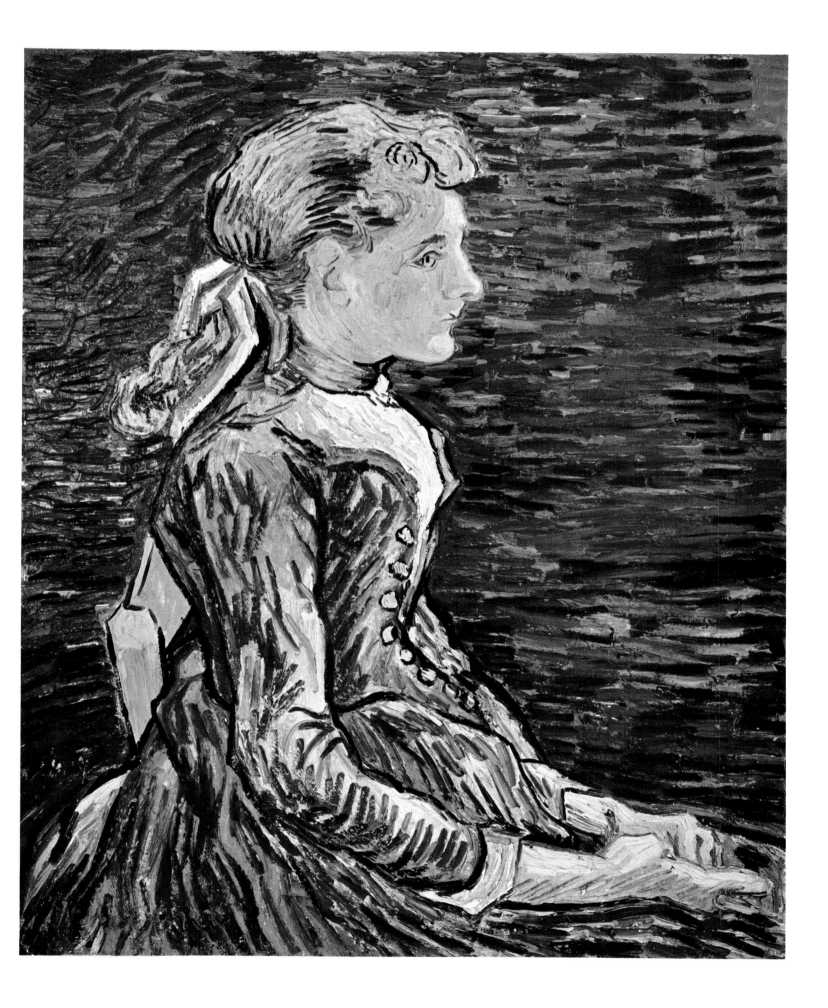

Painted July 1890, Auvers

CROWS OVER THE WHEAT FIELD

National Museum Vincent van Gogh, Amsterdam

$(19\frac{7}{8}'' \times 39\frac{1}{2}'')$

WRITING of this picture shortly before his suicide, van Gogh conveyed something of its tragic mood. "Returning there, I set to work. The brush almost fell from my hands . . . I had no difficulty in expressing sadness and extreme solitude." The singular format of the canvas is matched by the vista itself, a field opening out from the foreground by way of three diverging paths. A disquieting situation for the spectator, who is held in doubt before the great horizon and cannot, moreover, reach it on any of the roads before him; these end blindly in the field or run out of the picture. The familiar perspective network of the open field is now inverted; the lines converge towards the foreground from the horizon, as if space had suddenly lost its focus and all things turned aggressively upon the beholder. The blue sky and the yellow fields pull away from each other with disturbing violence; across their boundary, a flock of black crows advances towards the unsteady foreground.

And here in this pathetic disarray, we discover a powerful counter-action of the artist. In contrast to the turbulence of the brushwork, the whole space is of a primordial breadth and simplicity. The colours in their frequency have been matched inversely to the largeness and stability of their areas. The artist seems to count: one is the unique blue of the sky—unity, breadth, the ultimate resolution; two is the complementary yellow of the divided, unstable masses of growing wheat; three is the red of the diverging roads which lead nowhere; five is the complementary green of the untrodden grass of these roads; and as the *n* of the series there is the endless progression of the zigzag crows, the figures of fate that come from the far horizon.

As a man in distress counts and enumerates to hold on to things securely or to fight a compulsion, van Gogh in his extremity of anguish creates an arithmetical order to resist disintegration. He makes an intense effort to control, to organize. Elemental contrasts become the essential appearances; and in this simple order, the separated parts are united by echoes of colour, without changing the larger forces of the whole. Two green clouds are reflections, however dimmed, of the green of the roads. And in the blue of the sky is a vague pulsation of dark and light that resumes the great unrest of the ground below.

For further remarks on this painting see page 34.

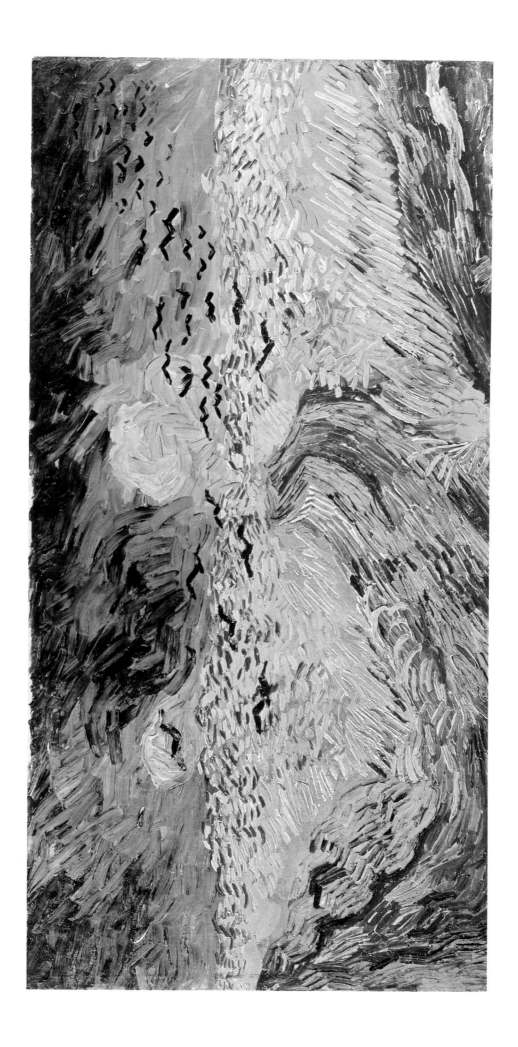

ACKNOWLEDGMENTS

The publishers wish to express their gratitude to those museums, galleries, and private collectors who so kindly gave their permission for the reproduction in this volume of paintings and drawings in their possession. For the quotations from van Gogh's writings we have made use of The Letters of Vincent van Gogh to his Brother 1872–1886 *and* Further Letters of Vincent van Gogh to his Brother 1886–1889, *edited and translated by Johanna van Gogh-Bonger, London and Boston, 1927, 1929; and* Vincent van Gogh Letters to Emile Bernard, *edited and translated by Douglas Lord, New York, 1938.*

NOTE

The text on page 29 to 34, and on page 130, has been largely excerpted from the author's article, "On a Painting of Van Gogh," *View*, 1946, pp. 9–14 (reprinted in his *Selected Papers*, Volume II, *Modern Art 19th and 20th Centuries*, George Braziller, Inc., New York, 1978, pp. 87–100).

In the dates assigned to the pictures, the author has changed certain of those used in the first edition (1950) to accord with the dates adopted in the revised catalogue of J.B. de la Faille, *The Works of Vincent Van Gogh, His Paintings and Drawings*, Meulenhoff International, Amsterdam, 1970. However, the original order of the plates has been retained.